Leah is an 18-year-old Canadian photographer and author. Since the age of 13, she has been mentored by Joel Sartore, a National Geographic photographer and Fellow. For the past four years, she has been traveling, with her dad, to cities throughout the world to photograph people experiencing homelessness and record their stories, such as Toronto, New York, and Brisbane. In July 2017, CBC's *The National* aired a mini-documentary about Leah. Since then her career has taken off. Most recently, she has been interviewed by, or appeared on, the BBC, the *Corriere della Sera* (the largest newspaper in Italy), *7Days* (a newspaper in the Netherlands), Global News, the *Toronto Star*, CBC radio, CBC's *The Goods, Chatelaine, Toronto Life*, and *The Agenda with Steve Paikin*, to name just a few. She has also spoken at such events as WE Day Toronto 2017, Women of the World 2018, and Cambridge She Talks 2018. Leah was recently the recipient of the Murray Clerkson Award, presented by the Blue Mountain Foundation of the Arts. She is currently in her first year at Sheridan College in Oakville, Ontario, where she is taking a four-year photography course.

To Lee Jeffries,
for showing me the way.

Leah Denbok
with Tim Denbok

Nowhere to
Call Home

Photographs and Stories
of People Experiencing Homelessness

Volume Three

AUSTIN MACAULEY PUBLISHERS™
LONDON * CAMBRIDGE * NEW YORK * SHARJAH

Ordering Information:
Quantity sales: special discounts are available on quantity purchases by corporations, associations, and others. For details, contact the publisher at the address below.

Publisher's Cataloging-in-Publication data
Denbok, Leah with Denbok, Tim
Nowhere to Call Home:
Photographs and Stories of People Experiencing Homelessness
Volume Three

ISBN 9781643786728 (Paperback)
ISBN 9781643786735 (Hardback)
ISBN 9781645364825 (ePub e-book)

Library of Congress Control Number: 2019953320

The main category of the book — PHOTOGRAPHY / Subjects & Themes / Street Photography

www.austinmacauley.com/us

First Published (2019)
Austin Macauley Publishers LLC
40 Wall Street, 28th Floor
New York, NY 10005
USA

mail-usa@austinmacauley.com
+1 (646) 5125767

Some Words of Introduction to Leah's Work

From Garry Glowacki, Executive Director, The Bridge Prison Ministry:

It is my privilege to offer this deep-hearted tribute to Leah and her many talents. Her photography skills are obvious. However, her greatest talent may be her ability to capture people at their most vulnerable in such raw honesty. It is a measure of her gentle, open, and brave spirit. As the director of a prison ministry that also works with homeless people, I often see glimmers of hope and portraits of humanity in the people I am called to serve. While I know a few of the people in Leah's portraits personally, her photos and short stories allow me to feel that somehow I know them all. I have purchased a number of her books as gifts for friends because they are so wonderfully real and they have all been cherished. I look forward to her next edition and photo show. I tell her she's the best, because she is.

From Larry Law, Owner and CEO, Living Water Resorts:

In 2001, as a result of my wife's death, I underwent a life-transforming experience. Previous to this, I had striven mainly to make money. However, as a result of this shattering experience, I saw the need to begin living, what the author Rick Warren has called, "a purpose-driven life," or a life based on God's eternal purposes. For me, as a resort owner, this meant that while I would still make money and do business to the best of my ability, my primary focus was to be on relationships, firstly with God and secondly with others. This led me among other things to begin, several years ago, to finance a Christmas dinner at the Collingwood Legion that feeds hundreds of people who otherwise would often have to do without. (Interestingly, I was recently told that Leah, as a young child, spent many years volunteering at this event.) I have also recently begun providing employment and a place to live for people experiencing homelessness.

Several months ago my friend Shawn Cooper gave me a copy of *Nowhere to Call Home: Photographs and Stories of the Home, Volume One.* I was *totally* amazed. How could someone so young produce so many touching photos that look into a person's soul in such depth? And so, when Leah's dad, whom I had never met before, approached me recently about writing some introductory words for this volume, I immediately said yes. I wholeheartedly support Leah's mission of attempting to change the general public's perception of people experiencing homelessness. I believe that God has a great purpose for this very talented, young woman.

From Gail Hoekstra, Executive Director, and Carlin Dykstra, Housing Stability Support Worker, Welcome In Drop-In Centre:

In many cities and small communities across Canada, the individuals and families that experience homelessness are often invisible to the greater community around them. People may walk by or see someone that is homeless, yet they feel a disconnection. They see homelessness as an experience that happens to "other people" not something that could ever affect them. However, Leah's work bridges the gap between "us" and "them" by bringing the humanity to all the faces of these individuals. Leah does a wonderful job of highlighting the heart and the struggle that everyone can relate to. People that experience homelessness have families, they have favorite foods, pets, jobs, goals, and dreams along with their struggles. Leah's photographs capture the story of homelessness with all of its rich complexity in an image and through conversation.

As we have followed Leah's work, we have been amazed by the hardships that some people have had to endure, but we are also greatly inspired by their determination and resilience to make the best of their situation, and their drive to keep moving forward in pursuit of their dreams. Leah's work also captures this spirit of hope, humor, and importance of relationships and connections within the community. It is our hope that as we share Leah's work, more people will be able to understand that homelessness is often not a choice. A

11

Guelph resident, Judith Rosenberg recently spoke of her experience with homelessness and said:

"There are many stories, and mine is a tiny one compared to others… I had no home and no money to pay for a place. Homelessness has many faces. We mustn't judge. Every story has its own beginning and end. Many are a divorce away…a lost job away…an illness away… from experiencing homelessness."

Together, we must understand that erecting social and economic barriers, and socially excluding those who are experiencing homelessness and struggling with life will only hinder us all. Instead, we need to understand people's stories, build meaningful relationships and stand together, which will make us a stronger and more vibrant community overall.

Thank you, Leah, for bringing the humanity and heart to the faces that we see each day as part of us and our community. We all grow from hearing the stories of the wonderful people that you meet!

Preface

In this preface, I would like to take the opportunity to give credit to the many people who have influenced the work I am doing with people experiencing homelessness. There are five people, in particular, to whom I am most indebted. They are, in no particular order: Joel Sartore, Lee Jeffries, Mother Teresa, and my parents, Tim and Sara.

When I was 14 years old my mentor, Joel Sartore, who is a National Geographic photographer and Fellow, suggested that I begin focusing on portraiture. He said that in his experience, successful photographers focus primarily on one genre, and he believed that my strength lay in portraiture. And so I began, with my parent's help, to photograph senior citizens in a couple of local nursing homes. However, the requirement by these institutions to get written consent from the children of these individuals soon made doing this impractical. It was then that my dad came across the work of the British photographer Lee Jeffries (to whom this book is dedicated). Jeffries is famous for his photographs of people experiencing homelessness. My dad suggested that I begin doing the same. And so, within a week I was in Toronto, with my dad, photographing these people. When my dad sent these first

photos to Joel, he said, "This takes Leah's photography to a whole new level. Keep going."

For as long as I can remember, I've known that my mother was saved by Mother Teresa. When she was just three years old, my mother was found wandering, alone, on the crowded streets of Kolkata, India, by a police officer. She had several deep cuts on her head, and was probably bleeding at the time. Knowing that Mother Teresa never turned any children away, the officer took her to Nirmala Shishu Bhavan, Mother Teresa's orphanage in Kolkata. There she was raised until, at the age of five, she was adopted by a family from the small town of Stayner, Ontario (pop. 4,029). In 2014, my mother wrote a booklet about this experience called, appropriately enough, *Saved – By Mother Teresa.* She frequently gives talks on the subject. On the wall of our living room hangs a painting of Mother Teresa that my father, who is an artist, painted years ago for my mother as a birthday present. So although Mother Teresa died three years before I was even born, I've always felt her influence upon my life.

My mother's story of having been homeless herself at a young age influenced me, in part—even if only subconsciously—to try to help people experiencing homelessness. It is only fitting, therefore, that we have begun giving talks together. First, she tells her story of having been homeless at the age of three and of having been rescued by Mother Teresa, then I talk about the work that I am doing with people experiencing homelessness.

My dad has been my constant companion since the beginning of this journey. Officially, he is my manager. As such, because I am so busy with college and my

homelessness project, I forward all inquiries pertaining to my homeless project (e.g. exhibitions, speaking engagements, questions, etc.) to him. Also, as I mentioned above, it was initially my dad's idea for me to begin photographing people experiencing homelessness. It was also he who suggested that I begin this book series. Furthermore, he accompanies me on virtually all of my photoshoots. (The only exception was when my mother did this while the two of us were in Brisbane, Australia, for the Women of the World 2018 festival.) He does this partly for safety reasons, but also so that he can interview the individuals while I photograph them. Lastly, my dad helps me write these books and edit my photographs.

Needless to say, I wouldn't be where I am today without the help and support of my parents. I will never be able to repay the debt I owe them.

As well as Joel Sartore, Lee Jeffries, Mother Teresa, and my parents, Sara and Tim, there have been several others who have assisted me, in one way or another, along my journey. They include: Alex Zafer, Tamarra Kennelly, Ernie McCay, Mike Jordan, Ron Kilius, William Vancise, Nicholas Clayton, Kevin Hiebert, Peter Stranks, Tannis Tooey, Stephen Bulger, John Gabriel, and all of my professors at Sheridan College. To all of the people on this list, and any others who I may have forgotten: THANK YOU FROM THE BOTTOM OF MY HEART!!!

— Leah Denbok

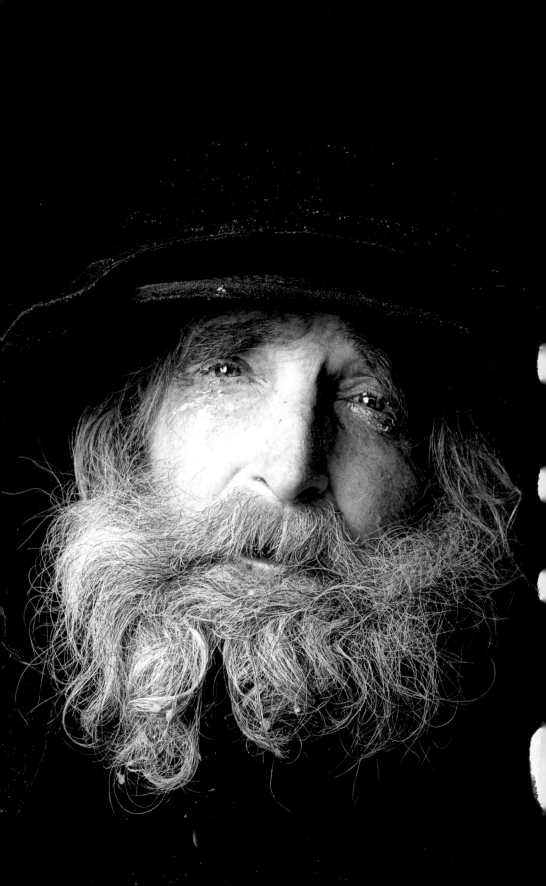

Allan

*W*hen my dad approached Allan about going outside to have his photograph taken by me, he hesitated. Since the temperature outside at the time was -11° Celsius, and Allan was enjoying a nice meal in the warm confines of the Welcome In Drop-In Centre in Guelph, his indecision was understandable. Nonetheless, he kindly obliged. But after he bundled up in his winter gear and began making his way to the end of the parking lot where I had my camera equipment set up, he turned to my dad and said, "You had to pick the coldest day of the year for this, didn't you?" Later he told us that it was "as cold as a mother-in-law's kiss."

Although Allan has lived in Guelph since 1975, he was born and raised in Scotland. "I came over with my wife at the time," he told my dad.

"Do you mind if I ask you what happened with your ex-wife?" my dad asked Allan.

"She…as far as I know…she's still in Calgary. That's where she went to. But I've made no attempts to make contact with her again. When things are over, they're over."

When asked if he misses Scotland, Allan replied, "Sometimes, but things are a little unsettled there right now. It's hard to know what's going to happen. The good times there may be over because the oil is running out." Allan told us that before his mother passed away in 2013, he would visit Scotland twice a year, but that he hasn't been back since.

Allan said that he frequents the Centre "most days." When asked if he has a lot of friends there, he replied, "Some friends and some detractors."

"Are the staff here good to you?" my dad asked him.

Allan thought about the question for a few seconds, then said, "Ahh…I would say I'm well-treated on the whole."

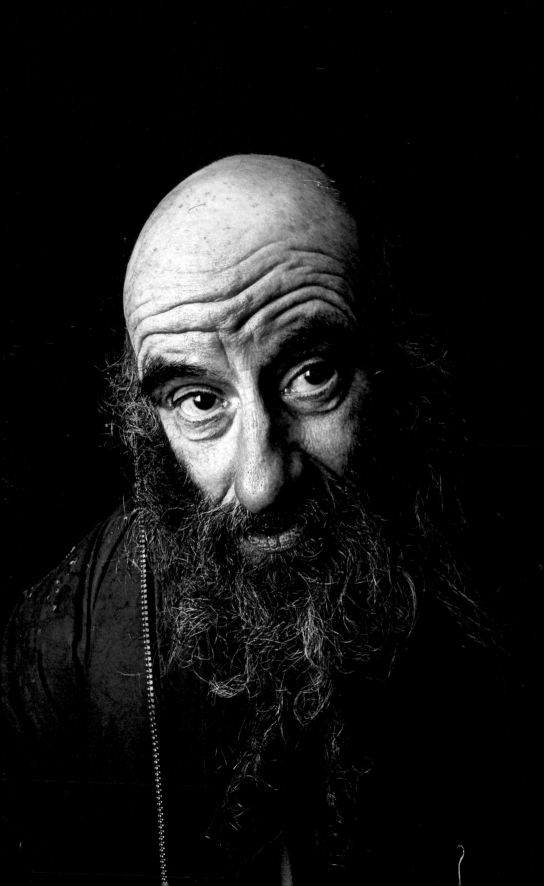

Donald

*I*t was a cold, March day in 2018. My dad and I had been busy putting up posters for an upcoming book signing and exhibit that I would soon be having in Toronto. While we were in the area of the Eaton Centre, we decided to see if we could find any people experiencing homelessness to photograph and interview. As we walked along Yonge St. beside the massive mall, Donald, looking disheveled and wearing dirty, poorly fitting clothes, walked quickly past us. As my dad had been looking elsewhere, I pointed Donald out to him. My dad quickly caught up with Donald, and after introducing the two of us and explaining to him what we were doing, asked him if he would be willing to be photographed and interviewed for $10. He happily said that he would. Unfortunately, despite the fact that we taped the conversation and although he spoke a lot about such things as working on a ship, Kentucky Fried Chicken, and trying to find his parents, we could make out little of what Donald said to us, or at least little that made any sense. But as with many of the people experiencing homelessness that my dad and I have met over the past 3–4 years, he was very affable.

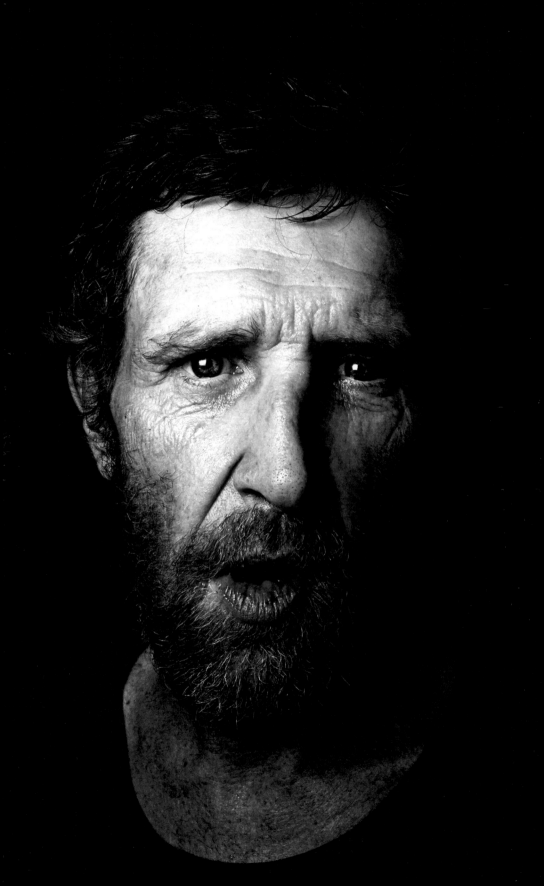

Shawn

Shawn told my mom and me that he has always lived in Australia. "Yeah," he said. "I've been as far as Townsville. Sorry, I've been as far as Ingrim and Cardwell. And that's about as far up North as I've been. And…um…I haven't been to Sydney since I was a kid. Yeah." He also told us that he has family in Australia with whom he maintains contact. "Yeah, yeah," he said, "Mom lives over in Inala. Good old Inala. Yeah, my younger brother and my mother."

"Do you have any children?" my mother asked Shawn.

"I have four kids," he replied. "A 12-year-old daughter, a 10-year-old son, a 9-year-old son, and an 8-year-old son. Yeah, one girl, three boys. Two are up in Townsville, and two are down here in Cairns at the moment. My wife committed suicide… I went back to using drugs. All that sort of jazz. Roughin' on the streets. Then I met Radda. Radda got me off the streets, and [she] helped me find a place to stay through the Salvation Army, when she used to be a Salvation Army worker."

When my mother commented to Shawn that he seemed happy, he responded, "Yeah, I'm always happy. Why be miserable? You only live once. I went through a bit of a downer in life once, at one stage. But… um…yeah. I snapped out of that. I've been off the drugs now for about eleven months clean."

Shawn proudly told us that he once volunteered at the Brisbane Streetlevel Mission, run by the Salvation Army, for five years. "Yeah, they help me," he said. "So I thought, why not? You know?"

"Do you feel safe on the street?" my mother asked Shawn.

"Yeah, yeah," he said, "of course. Yeah, because I know a lot of people. It's like a little community. Do you know what I mean? Everyone-knows-everyone sort of thing. We look after each other, you know? We help each other when we can. Well, some of them do." Then, looking in the direction of some of his friends who were standing nearby, he shouted, "Some of them are just freeloaders!" a remark which aroused a chorus of protests.

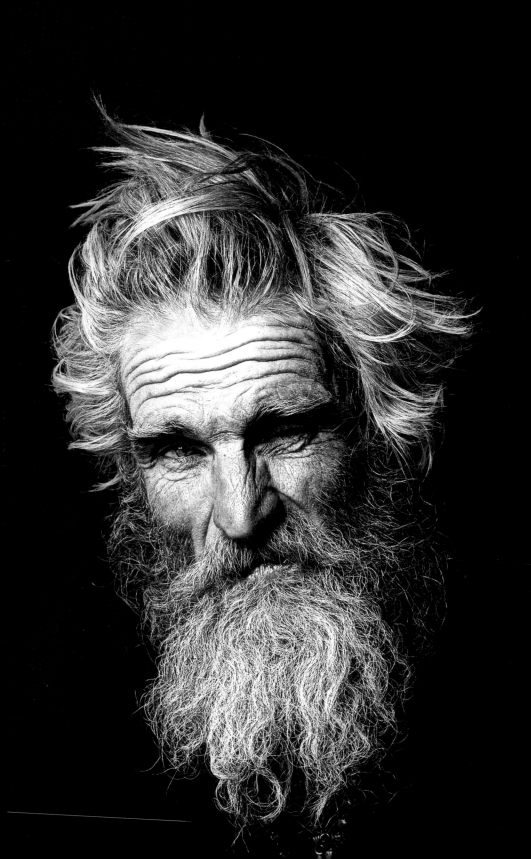

Duffy

"**M**y old man's passed away," Duffy declared to us. "Everyone's passed away. My grandmother's passed away. She outlived her kids. I wouldn't like that! But she still had her mind." But despite the fact that Duffy seemingly has fond memories of his family, it seems that all was not well with his relationship with them. "I was a ward of the court at four," he told us sadly. "I've been on my own since four."

Duffy, who is 58 years old, was born and raised in the GTA (Greater Toronto Area). "I was born in York, the first capital of Canada," he told us with a note of pride in his voice. However, he grew up in Brampton. "It was thirty thousand when I moved there in '64!" he said excitedly. "Thirty thousand people!" Duffy has traveled the country from coast to coast. When asked what his least favorite place to visit was, he replied, "I'd say the toughest city is Winnipeg, Canada… This is a tough city here. Hamilton's a tough city." When asked what his favorite place to visit was, he said, "Actually, it was the Rocky Mountains."

"You've got a nice Philadelphia Flyer's ring on your finger there!" my dad said to Duffy.

"Yeah, 1974," he said as he held it up proudly.

"Is that the Stanley Cup ring?" my dad asked him.

"Yeah, it's got some time on it too," he replied. When my dad mentioned to Duffy that it probably had some value to it and that there were likely some people who would want to get their hands on it, Duffy replied, "They wouldn't get it off my finger. They'd have to take my finger off."

When we met Duffy, he was sitting on a bench, just down the road from the Salvation Army's Hamilton Booth Centre, chatting with his friend Mike. Later Mike said of his friend, "He's the nicest guy. He'd give you the shirt off his back!"

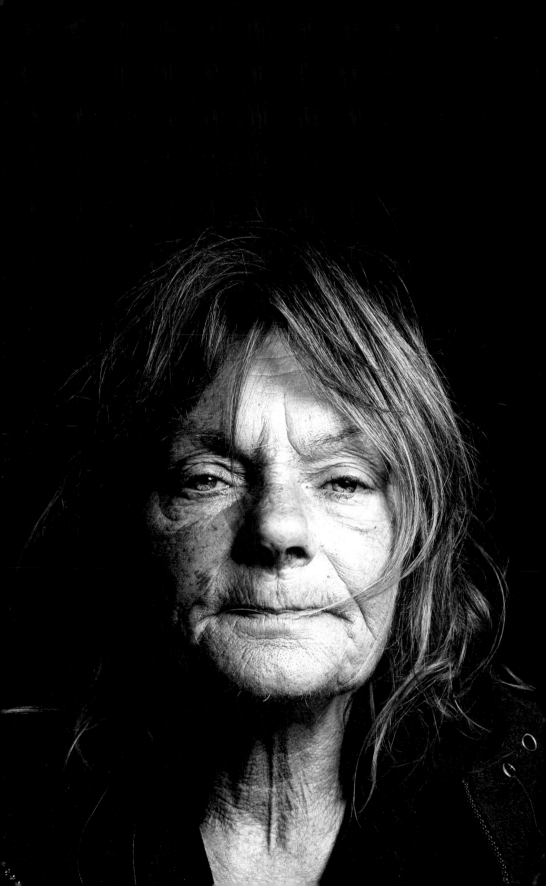

Becky

When my dad and I came across Becky, she was in a bit of a rough spot. She was sprawled out on the sidewalk, sound asleep, at the corner of Yonge and Adelaide in Toronto, less than a meter from the busy road. This was in October of 2017. As he was concerned for Becky's safety, my dad had no qualms about waking her up. She also looked as if she could badly use the $10 we pay all of those who model for me.

Although Becky agreed to have her photograph taken and be interviewed, she said little. Most of her answers were of the "yes" or "no" variety. However, she did say that she was born and raised in Peterborough and has lived in Toronto for forty years. She also said that she has no family and stays at shelters when the weather gets cold. When it was time to say goodbye and I told her that it was nice meeting her, she replied, "It was good to meet you too."

After I posted the above photo and story of Becky on Instagram, I received the following comments:

'I just want to thank you for being so nice to her. I am adopted and Becky is my birth mother.'

— Amanda

'Becky was a childhood friend and a wonderful person. This is what happens when mental illness and life beats you down over decades…you are loved, Becky.'

— Barb

'Thank you for sharing. Becky is the sister of my longtime friend of 30+ years, Jean. Incredible we never knew what happened to her since she disowned her family and left for the big city. Life's too short. I hope she keeps well.'

— Jennifer

'Hi there. My name is Nikki and I'm a friend of Dave. Dave is the brother of Becky, the one you have photographed. Dave has not been in touch with his sister Becky. I was wondering if you have any information in regards to contacting or tracking Becky down. If you do, pls pls pls pls pls pls pls forward me her contact information.'

— Nikki

Sadly, Becky was struck and killed by a car several months after my dad and I met her.

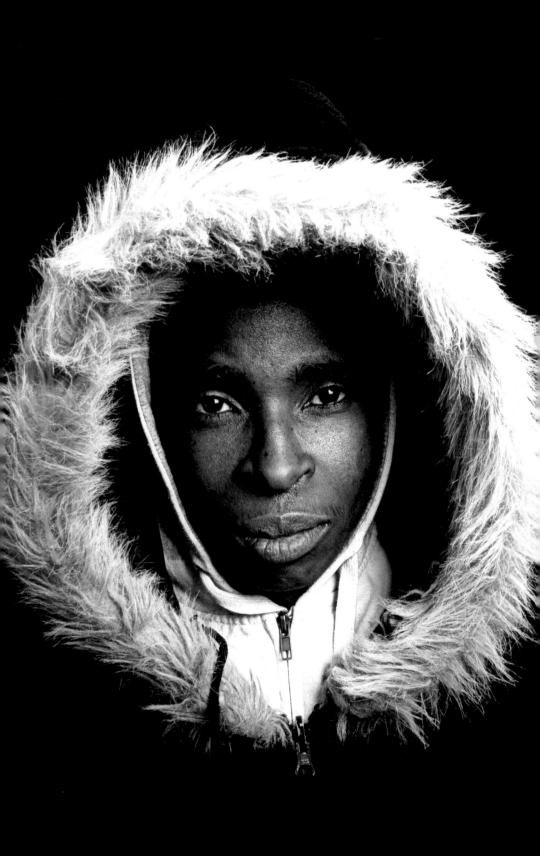

Rockel

*W*hen we met Rockel, she was standing outside of the Seaton House homeless shelter in Toronto talking to friends. My dad asked her, "So, can women stay here as well?"

"No," she replied, "it's just for men." She then told us that she was staying at Adam's House, a supportive housing program that was just around the corner on Sherbourne Street.

Although Rockel has traveled extensively to countries known for their warm climates, such as Jamaica, India, and Mexico, when she was asked by my dad if she likes Canada, she surprised him by answering, "Yeah, it's beautiful. I like it here. I love it!"

"Sounds like you like the warm places," my dad said. "And yet you're living in Canada!?"

Her reply was succinct, "I've been to Vancouver... It's nice in the winter." When asked where she hoped her travels would take her next, she said Jamaica, or her favorite place to visit, Mexico.

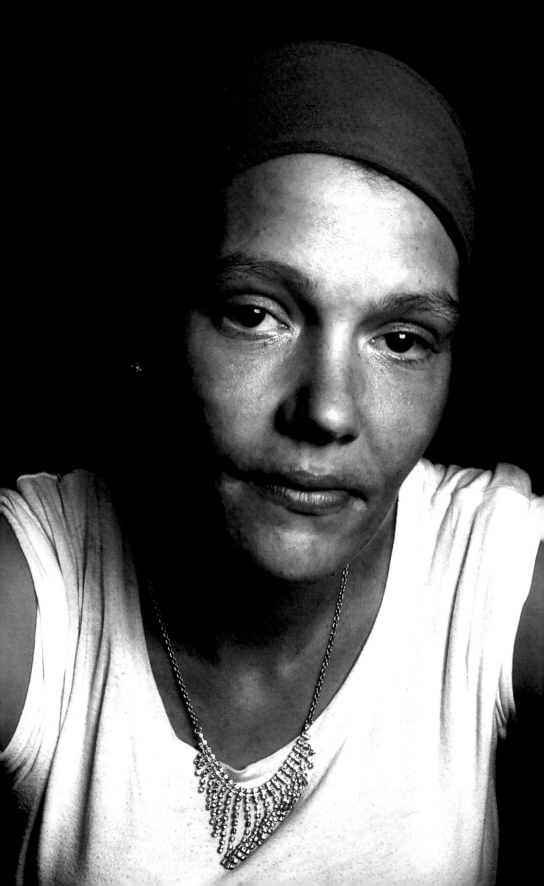

Kimberly

*U*p until three years ago Kimberly, together with Matty, her partner of eleven years, and their seven children, all lived together in a house of their own. "In 2015 we had a house fire," she told us. "Everyone was okay, but we lost the kids to Child Safety. And we ended up homeless. It's hard to get out of that circle, you know what I mean? Because we have adapted to that lifestyle and the…friends we have also adapted to the homeless lifestyle." It probably doesn't help that Kimberly herself was first homeless when she was just eleven and then again when she was seventeen. Sadly, Kimberly now feels as if everyone, including social services, has given up on her and Matty.

Kimberly told us that her children were her life and that losing them has been very hard on her. However, she does see some of them every Friday. (She sees the boys one week and the girls the next.) This has helped, somewhat, to ease her pain.

Kimberly's immediate goal is to find a job. This will enable her to get a place of her own. (She currently sleeps under a bridge.) Then, hopefully, she will be able to get her children back. There is only one small problem though: her identification was lost in the fire, and without it, she can't get a job.

Although still only in her twenties, Kimberly says that she feels old. Prolonged periods of stress will do that to you. Adding to her anxiety are the many quarrels that she and Matty have.

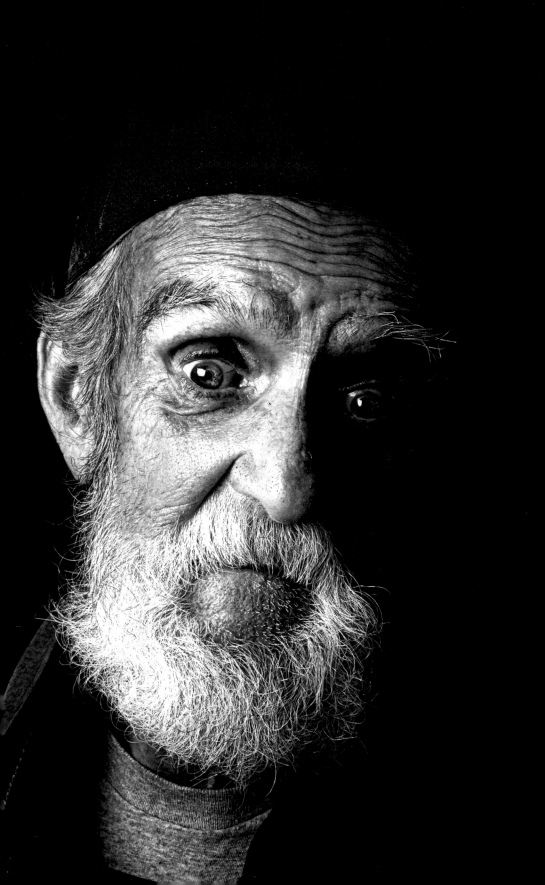

Glen

When my dad and I met Glen, he was down in the dumps. "She's kicking me out," he said despondently. "My niece, my…my nephew's wife. One minute I'm there, the next minute she's kicking me out again. And I'm getting pretty frustrated sleeping on the street." Within a few minutes, however, the conversation had turned to better days and happier times. When my dad told him we live in Collingwood, he excitedly told us of the time he once worked there. "Yeah, I used to work in the shipyards over there…grinding," he said. His mind then quickly turned to the time when he found employment on a farm. "Best life I had was working on a farm. I love farm work. The only job I didn't like was picking stones. I'd walk in… I'd look like a deformed dog." At this, he laughed uproariously. "I'm enjoying this!" he exclaimed. "Thanks a lot for coming and getting me, man! This has upped my spirits." He said, "Then I used to sail on the big boats. I was a wheelsman on the big lakers, eh? Oh, I made good money…$36,000 a year back then."

Glen, we learned, has a college degree, having studied machinery in Toronto. Towards the end of the photoshoot, he nodded in my direction and, to my dad, said, "Is she in high school?"

My dad told him that I was in grade 12 and that, upon graduating, I was planning on studying photography at college or university.

He then turned to me and said, "Good for you, honey! Keep going! Don't stop! Education is most important."

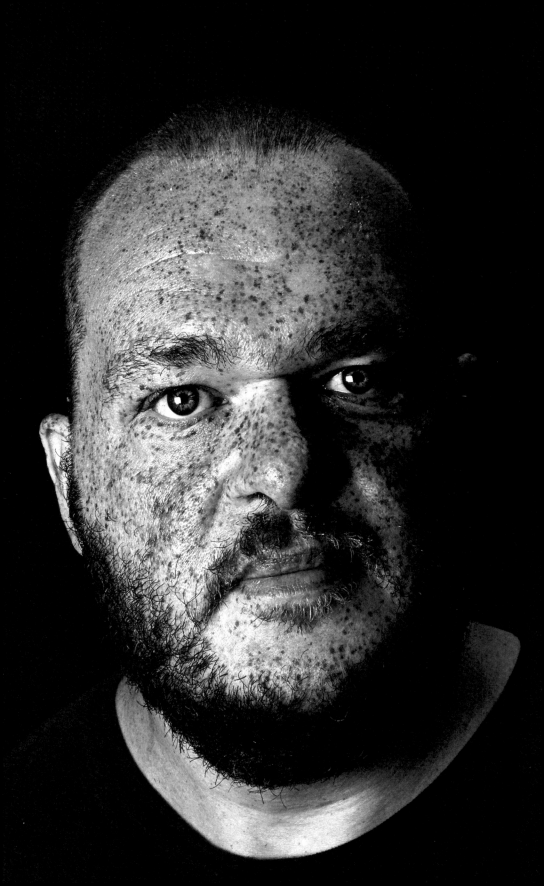

Patrick

"*I* haven't been homeless for very long," Patrick told us. "Just a couple of months."

"What happened, if you don't mind me asking?" my dad asked.

"I was illegally evicted," Patrick replied. "Ah, the place ended up being illegal, and, ah…I was scammed out of a place, and, ah, the people I gave my money to weren't the landlords, and there's a knock at the door and it's the actual owners of the place. And, ah, all my stuff is gone. Everything is gone."

My dad mentioned to Patrick that it would be good for people to hear his story, since a lot of people have the mistaken assumption that homeless people are just lazy. However, what happened to him could obviously happen to anybody.

Patrick replied, "No, definitely! I was a successful businessman. I was into radio. I ran my own company for a while… I used to be a childhood actor, and, ah, I was on *Mr. Dress-Up, Maniac Mansion*. I've met Nelson Mandela. I used to be a singer, and, ah, was very successful at it."

When we met Patrick, he was staying at The Stepping Stone homeless shelter in Guelph. He hopes this will soon change. "My time is almost up there," he told us. "I'm trying to get an extension, but it all depends on…it's a case-by-case… I've been looking at places. In fact, I'm looking at two places tomorrow."

"Good luck to you," my dad said.

"Thank you!" Patrick replied.

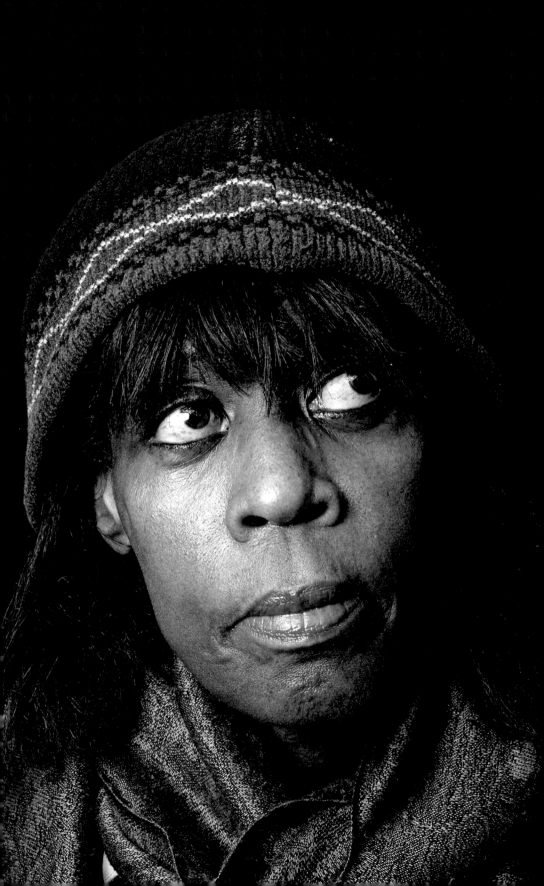

Renee

When my dad and I met Renee outside of the Life Women's Center in Manhattan, she told us, sadly, that almost all of her family had died. Then, in a singsong voice, she exclaimed, "But I'm a grandma. I'm a g-a-m-m-a… I'm a g-a-m-m-a. I'm so happy I'm a grandma."

"How old are your grandchildren?" my dad asked Renee.

"My granddaughter is one month and, I think, three weeks," she replied. "And my grandson is, I think, two weeks."

"So you must have at least two kids?" my dad said.

"That's *exactly* what I have," Renee replied. Then, kidding around with us, Renee said, "One named Hungry, and one named Greedy. If I get one more they're going to be starving."

Towards the end of the photoshoot, Renee playfully exclaimed, "I'm still beautiful. Can I still be a model?"

"That's what you're doing, modeling," my dad replied. "You're modeling for Leah. That's why we're paying you."

"I used to be really pretty," Renee told us.

"You're still pretty," my dad responded.

"No," she insisted, "I used to be pretty."

Renee had only agreed to participate in the photoshoot on the condition that afterwards she could see the photographs that I had taken of her. However, no sooner did I show her one of them than she jokingly let out a scream and exclaimed, "My eyes are huge!"

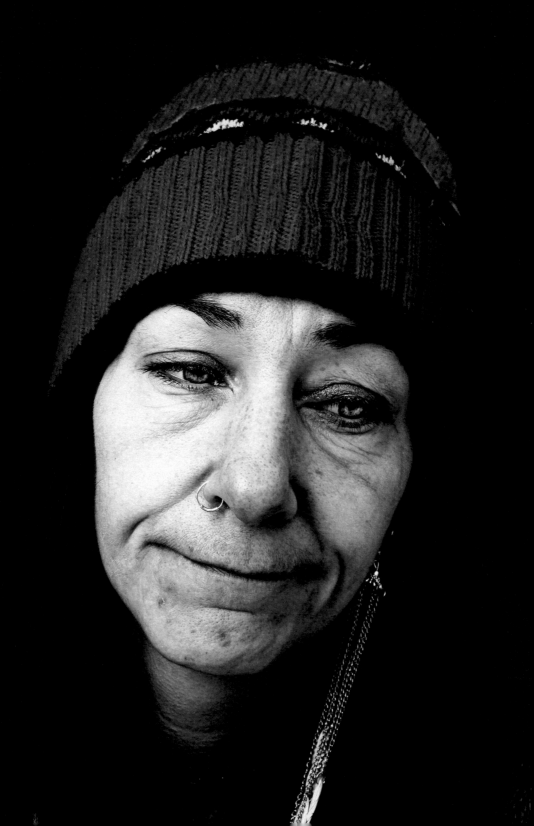

Genevieve

"*I* had ten children and lost them," Genevieve told my dad and me. "It's been downhill since."

Hearing this, my dad exclaimed, "Wow! You don't look old enough to have ten children."

Genevieve, obviously flattered, laughed and sheepishly admitted to us that she was thirty-nine. Her children, she told us, range from two to twenty-five. Asked if she has contact with them, Genevieve replied, "Not at the moment, no. But I'm working on that." She told us that she and her children's father are working to get their children back. "We're trying to fight it because there was some corruption in the process," she said. She told us that her children, with the exception of the oldest, are "scattered" with some in Huntsville, and others in Beaverton. Her oldest child is now twenty-five and lives in Orillia.

"Do you have contact with him, since he's an adult?" my dad asked Genevieve.

She nodded and said, "My only sanity left."

Since Orillia doesn't have a women's shelter, Genevieve has been forced to "couch surf."

"They don't really have a woman's shelter here," she told us, "unless you're abused." When Genevieve was asked where she sees herself in five years, she laughed and said, "Hopefully in a better spot."

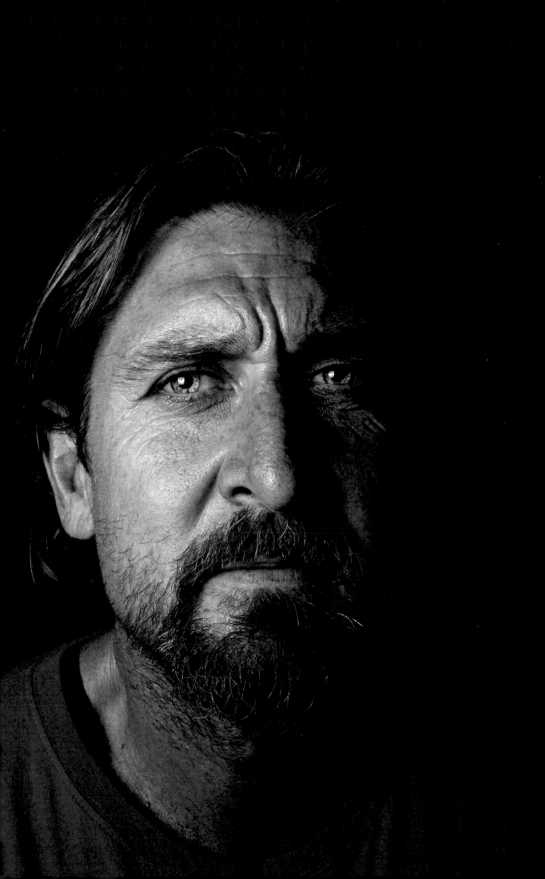

Barry

"*I*'m a window tinter," Barry told my mom and me. "I tint car windows."

"How do you do that?" my mother asked him.

He replied, "Just soapy water and, um, a bit of film… It's pretty simple. You spray soapy water on, then you roll the film so that it sticks on. The sticky bits on the back of the film. It's a good job."

"Does it pay well?" asked my mom.

"Very good!" was his response.

Barry went on to tell us that when he was younger he also used to tint the windows in mansions and high-rise buildings.

"I've *never* heard of such a job," exclaimed my mother. "That's a great job. Good for you."

"You're the first window tinter that we've met!" I chimed in.

Laughing, Barry replied, "There's always a first."

Barry then went on to tell us that he has also been employed as a farmhand. "I drive tractors as a farmhand," he said, "I drive tractors, forklifts. I'll get back into it one day."

"Is that a goal in your life?" my mother asked him.

"I definitely want to get back into work. I'm only 39… I'm still young."

We managed to find Barry with the kind assistance of Micah Projects, an organization in Australia that provides a variety of supports for people experiencing homelessness. When my mom asked Barry if he had received help from Micah Projects, he replied, "Oh yeah, for sure. They give you housing too, eh? I'm with Micah Projects to get housing. But it might take three years. And I've never had a house before, so… [I've] never had a place to live before, really, you know? Just traveled, mostly on the streets. As I said, I worked on farms too for about 7 years, and I traveled around. I was on the street, but still living in a tent."

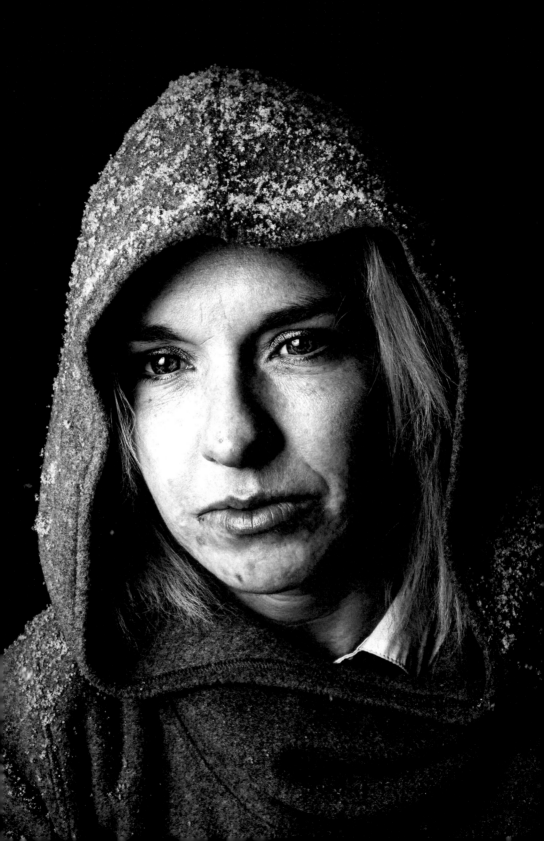

Amy

"*A*ll my exes don't live in Texas, they live in federal institutions," Amy told my dad and me, laughing. Though born and raised in "small-town New Brunswick," Amy settled in Ottawa at the age of twenty. A year ago she moved to Guelph to be with a man who she had met. "I came up with a man. And broke up with him, and stayed for a different man, who is now in jail… He was on the run for six months. Then they finally caught him."

Amy told us that her recent choice of men has caused discord between her and her dad, who lives in Toronto. "I broke off contact with him this past summer because of the guy I moved here for," she said. "Do you want a soap opera? I can tell you a soap opera," Amy said, laughing.

However, it soon became apparent that Amy's laughter concealed a deep-seated sadness that she carries around in her heart. "I…um…I'm thirty-six now, but I was widowed at twenty. He died saving my life in a house fire. After that, I had to leave New Brunswick." Asked if she and her late husband had children, she said, "No, we were just starting to try."

My dad said, "That's a very sad story."

Amy replied, "Yeah, it sucks!"

When my dad mentioned to Amy that we live in Collingwood, she replied, "I've heard of it. I think I've been there." Upon being told that Collingwood and Wasaga Beach are just down the road from each other, she exclaimed, "Oh! Yeah, I've been [to Wasaga Beach]… with my dad when I was a kid."

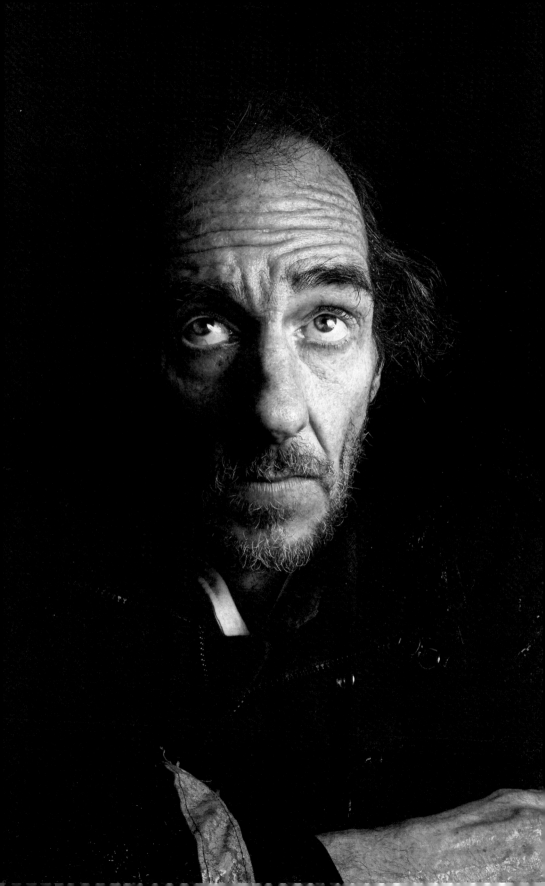

Freddy

*W*hen we met Freddy outside Seaton House in Toronto on a wet, dreary day in November of 2017, he was just heading out the door to go for a walk. He kindly agreed to postpone his stroll for a few minutes so that I could do a photoshoot with him.

Freddy told us that his mother, who is in her 60s, lives in New Brunswick, though she sometimes comes to the city to see him. "She came to visit me last year," he said. He is the oldest of four children. However, he told us that he has no contact with his three siblings. And so, except for the few friends Freddy has made at Seaton House, he is alone in a metropolitan area of almost six million people.

Though friendly and cooperative, Freddy responded to most of my dad's questions with a simple, "Yeah." That is until the conversation turned to that of his father who died fifteen years ago. With an earnest look in his eyes, Freddy looked up at my dad and asked him, "Do you believe, like, if someone passed away, like my father passed away, he could be in heaven right now?"

My dad replied, "Yes, I do."

"Where you close to your father?" my dad asked Freddy.

He responded with a nod of his head.

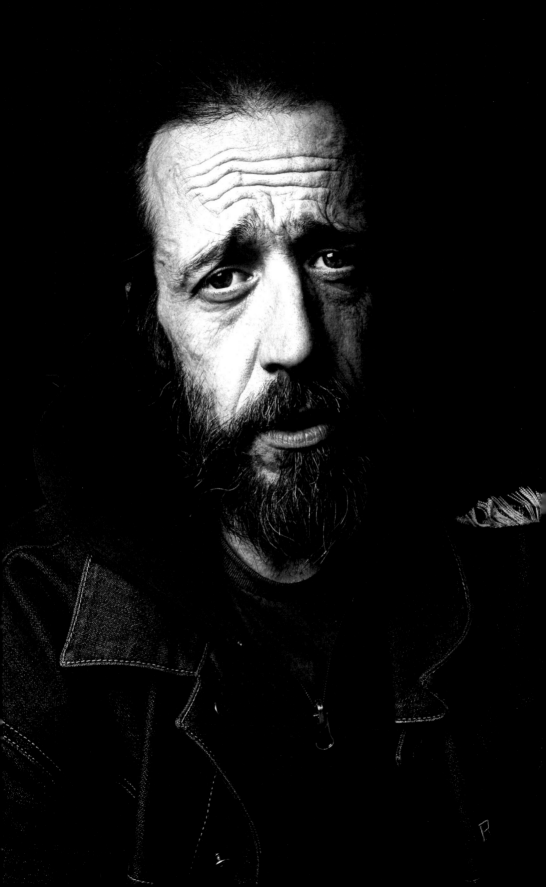

Andrew

*W*hile I was taking Andrew's photo across the road from the Eaton Centre, a woman suddenly stopped and snapped his picture. This prompted Andrew to exclaim angrily, "What are you doing, buddy?" After the woman hurried off, Andrew turned to us and said, "I don't mind people taking my picture, but at least ask. If you don't ask, don't take my picture." After my dad stated that he always makes a point of getting permission from the people experiencing homelessness whom I photograph, Andrew said, "And I appreciate that. It's not respectful. But it is what it is. What can you do? Like, I'm not going to get up throwing my fists around. Like, come on! Show me respect!"

When we met Andrew, he was sipping from a can of beer. When told that he could continue doing so while I photograph him, he replied, "Perfect! Isn't that the way it's supposed to be? We're supposed to accept people for who they are, not who we want them to be."

Andrew has lived in Toronto for about two and a half years. "I figured if I'm ever going to get on my feet, this is the place to be," he told us. "This is where all the jobs are at. The transportation's amazing."

When my dad asked him if he had sought help from the Salvation Army, he replied, "Uh, kinda. To be honest, like, I done the shelter system and they don't put out as much help as people think. There's people coming in and out. It's almost like an infestation. If you ask me, it's kind of asinine. They put [together] 200 guys all who are angry and frustrated, sad and depressed, and they have no one else to take those emotions out [on] except each other."

"Where do you stay when it gets really cold out," my dad asked.

Andrew responded by saying, "Sometimes, you know, we know a couple of people they take us in once in a while. Other than that, you gotta have as many blankets as you can, and you gotta have a heating grate and hope to stay warm."

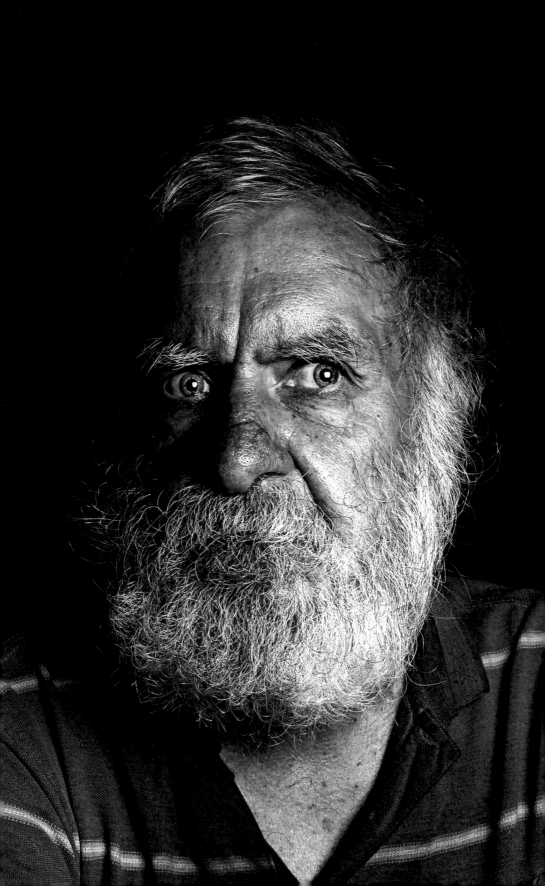

Ray

*W*e met Ray, who is personable and friendly, beside the Jeays Street Community Centre run by the Red Cross. My mom asked him if he often receives help from the Red Cross. He replied, "Yeah [they help me with] everything. I haven't got a home." However, when my mom asked Ray if he receives any assistance from the (Australian) government, his answer couldn't have been more different. He angrily responded, "No! No, definitely not!"

"Then it's good these people are helping you out," my mom said.

"Yes, they provide you with the necessities," he replied. "They're stopping a lot of crime because people steal to survive."

Then, despite the fact that the Centre was only slightly elevated, Ray said, "I gotta go back to town yet, back down the valley where I live. Yeah, I've never been here before. But, oh, what a place to come too, all uphill. Oh yeah, it's a wonder they have oxygen up here, it's that high."

Laughing, my mom replied, "You're a funny guy!"

To this Ray responded, "Oh, I'm alright. I think I'm happy actually. Yeah, you don't get anywhere by being sad."

However, Ray's countenance changed when my mom asked him if he had any future goals. Looking down at the ground, he replied, "No, not really." When asked if he used to have a job, he said, "Yeah, cable joiner. [I used to] join all the cables up."

"Do you think you might do that job again?" my mom asked him.

He replied, "Well, I could if I wanted to, but I'm retired, yeah."

When I had gotten all the photos I needed, I thanked Ray for his time and, shaking his hand, told him goodbye. Ray's parting words to us were, "Thanks very much. We'll see ya when we see ya. Have a good trip [back to Canada]."

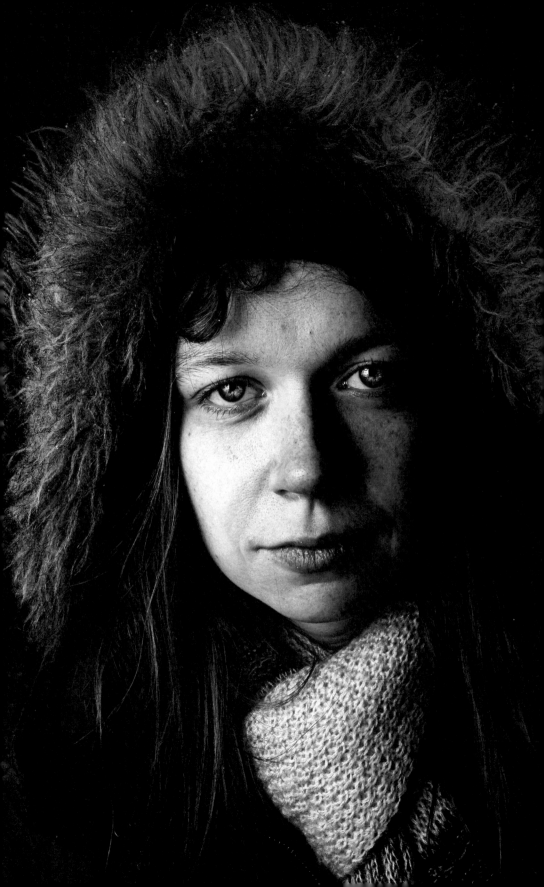

Dana

*D*ana told us that she has lived in Guelph her whole life. Although not married, she has been in a relationship with the same man for six years. Together they have a daughter, who is five years old. She also told us that her family lives in Guelph, and that she has maintained contact with them.

When asked if she had a good Christmas, Dana replied, "It was unusual. It was interesting."

"Did you eat the turkey meal at the [Welcome In Drop-In] Centre?" my dad asked.

"No, [turkey] makes me sleep," she replied, at which we all laughed.

As the photoshoot wound down, Dana suddenly said, "My eyes are watering!" This no doubt was the result of the wind and -11°C temperature. And so, since we were almost done anyway, we all headed back inside the Centre to warm up.

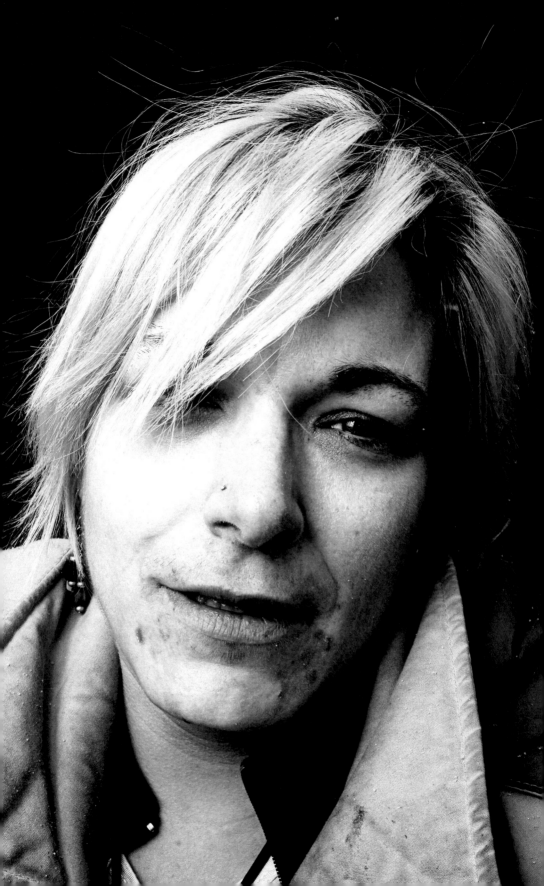

Barbara

*B*arbara was sitting with a couple of friends at a table in the Welcome In Drop-In Centre in Guelph when my dad approached her about modeling for me for $10. When she hesitated, he told her to think about it and that he would check in with her later. About 30 minutes later as he was walking past her table, she looked up at him and said, "Okay, I'll do it."

But as she and my dad stepped outside the building to where I was waiting with my camera equipment, the loud cawing of dozens of crows in a nearby tree filled the air, causing Barbara to give my dad a look of unease. Seeing this, my dad jokingly said, *"The Birds!"*, referring to the Hitchcock horror-thriller from the 1960s. Then, turning to Barbara, he said, "That doesn't sound too good, does it? That sounds kind of ominous."

"This is what I'm saying!" Barbara exclaimed, in a voice of mock earnestness. "They had to come out when it's my picture!" At this, they both cracked up.

Barbara told us that she has lived in Guelph for three years. Before that, she said, "I kind of bounced around from place to place [because of] circumstances and work."

"Do you like Guelph? Is it okay?" my dad asked her.

She replied matter-of-factly, "It used to be."

She then told us that she hopes, within the next couple of months, to move to the Okanagan Valley in British Columbia.

"Why there?" my dad asked her.

Her response was, "Tranquility. And the beauty... It's easier work. Easier...just easier living, period."

"Do you know anybody out there?" my dad enquired.

She replied, "Not a clue, and that's a perfect reason!"

Making it easier for Barbara to leave is the fact that, apart from a couple of cousins with whom she has no contact, she has no family ties here.

When, a couple of minutes later, the photoshoot was over, my dad turned to Barbara and said, "That wasn't too painful, was it?"

She replied, "No."

He then said, "You don't even have to see the pictures if you don't want to."

At this, they both laughed.

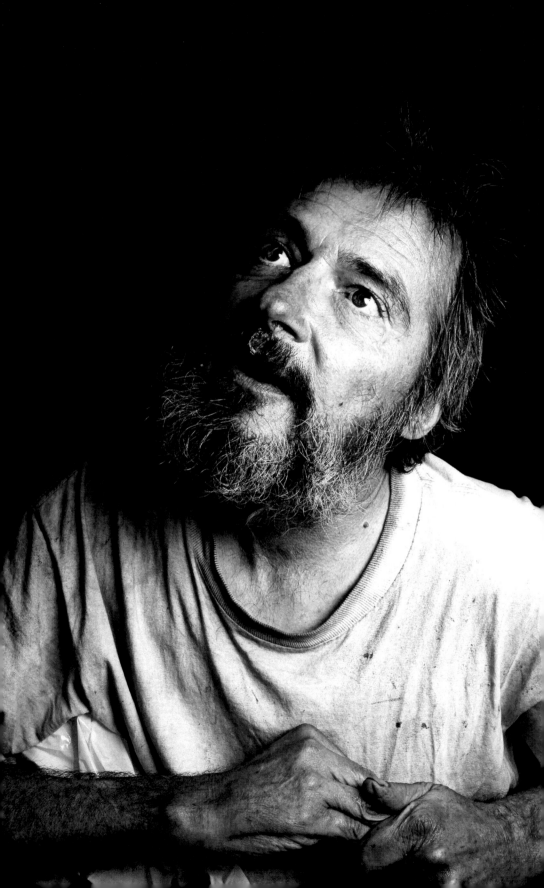

Randy

When my dad and I came across Randy, he was in a pitiable state. He was trying, with much difficulty, to push himself in his wheelchair up Yonge Street, a couple of blocks south of the Eaton Centre. When we approached him, he told us that he was lost. Having only moved to Toronto a couple of months earlier from the town of Courtice, Ontario, he did not know his way around. Exacerbating the problem was the fact that the people in the city, he told us, were unfriendly to him. "I find the people very mean to me," he said. "They steal things from me."

Randy told us that he is alone in the world, with no friends or family. "I've got nobody anymore," he said. "I've got nobody. I'm just in my wheelchair... Yeah, my dad died. My mom died a long time ago... I have two brothers and one sister, but they all died. I was the youngest. My dad died of a chain saw accident. A chain saw hit his stomach and cut him open. And my mom died of lung cancer. My sister died of scoliosis. And my brother died in a car accident."

Asked where he lives, Randy replied, "I have no place to stay. I stay in parks."

"What are you going to do when the winter comes?" my dad asked Randy. (This was in November.)

"I have no idea," he answered.

"I was a mechanic at one time," Randy told us, "but then everybody died on me. I got hit by a tractor trailer. Yeah, I got hit by a tractor trailer... That's why I'm in a wheelchair."

Before leaving Randy, I looked up, on my cell phone, the address of a store that he was trying to find. Since we had to begin our 2½-hour drive back to Collingwood, we then took Randy part of the way to the store before we had to say goodbye. Afterwards I felt bad that I didn't do more to help him.

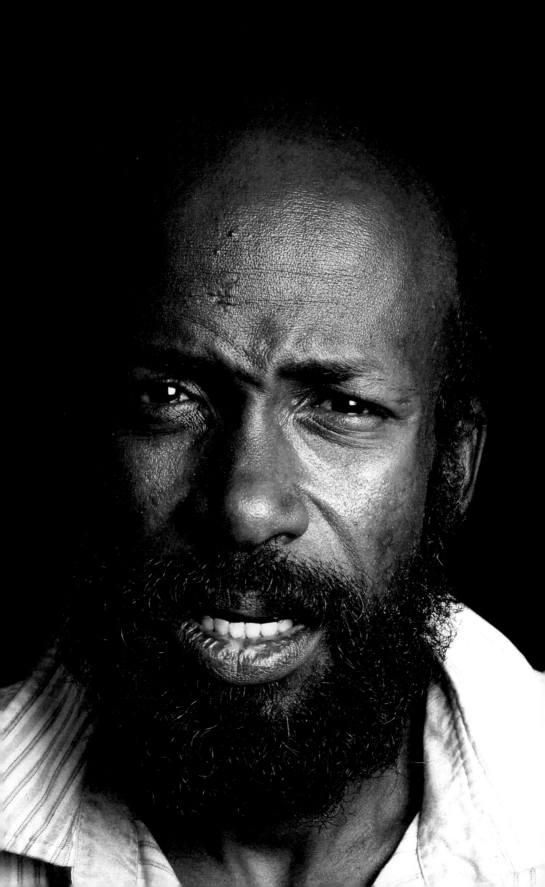

Nasser

*I*t was a mild September afternoon in downtown Toronto, and my dad and I had just finished doing a photoshoot of a man who was experiencing homelessness. Observing us pay the man for modeling for me, Nasser approached my dad with a big smile on his face and excitedly asked if I could take his picture as well. After, first, making sure that it was okay with me, my dad said that I could. However, no sooner did I begin than Nasser's demeanor immediately changed. As soon as I positioned my softbox diffusor in front of him, he complained that it was too close, saying, "Could you move that a bit back?" He then said, "I won't be able to answer too many questions." After about the second or third question, Nasser, in an annoyed tone of voice, exclaimed, "Is that enough?" When my dad told him that it would just take a few more minutes, he replied, "How much more minutes?" He then angrily exclaimed, "I didn't need [this to take] the whole day. I'm having a headache."

Not wanting to further irritate Nasser, my dad paid him and thanked him for his time. After taking the money, Nasser said, "I appreciate it. Thank you." He then quickly walked away.

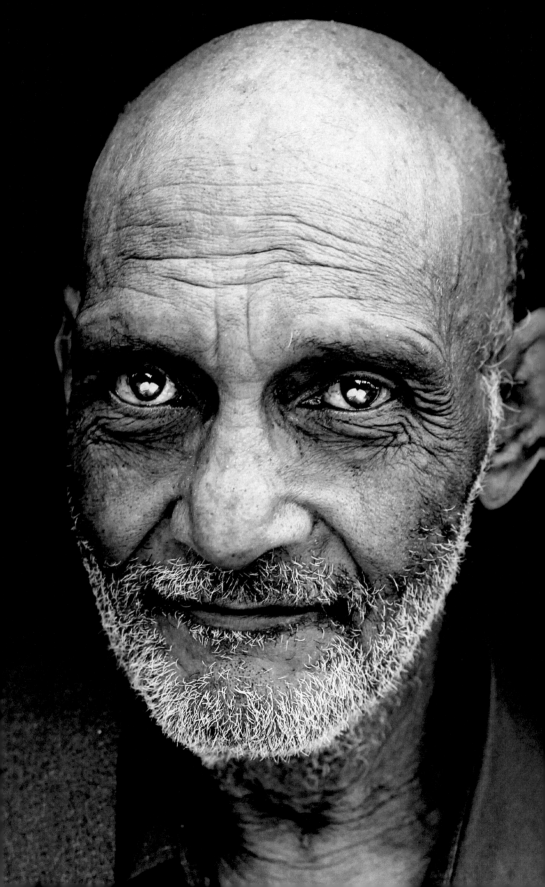

Lyron

*W*e met Lyron (not his real name) in Manhattan on a hot August day in the fall of 2016. Unfortunately, although we did get verbal consent from him to use his photograph, we had not yet begun to record the conversations that we had with people experiencing homelessness. As a result, my dad and I can remember virtually nothing about Lyron—including his name. We both remember, however, that he was very friendly.

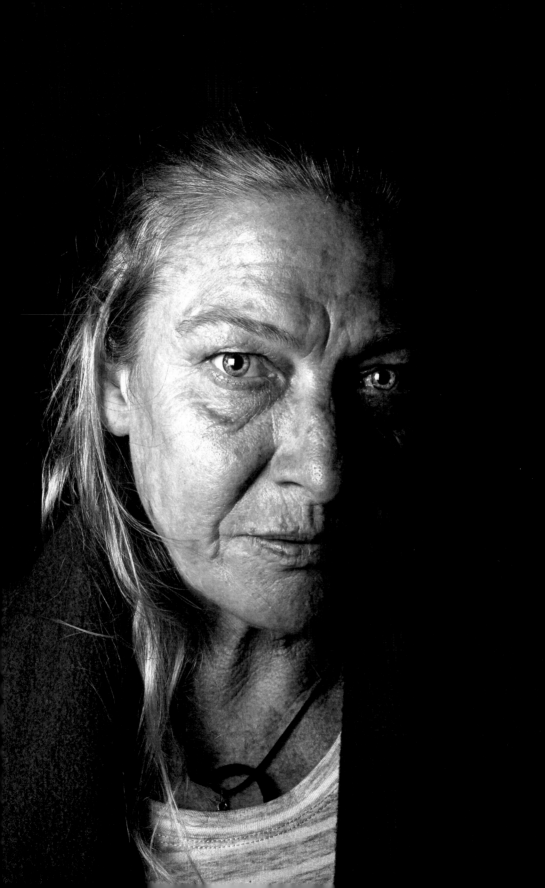

Darlene

I came across Darlene while my mom and I were in Brisbane, Australia, where I had been invited to exhibit my photography and speak at the Women of the World 2018 festival. I was introduced to her by a staff member from Micah Projects who had kindly offered to drive us to a few homeless shelters. "Micah Projects," the organization's website says, "is a not-for-profit organization committed to providing services and opportunities in the community to create justice and respond to injustice."

We met Darlene at a busy intersection as she was getting her supper from a food truck run by Mormons. It was 7:00 p.m., and already dark. The temperature was mild.

Darlene, we were to learn, was born and raised in Brisbane. In fact, her family, including her two children, who are aged 19 and 20, still live there. "Do you have contact with them?" my mother asked her.

She replied with a simple, "Yes."

When asked how she ended up being homeless, Darlene told us matter-of-factly, and without elaborating, "I met someone I shouldn't have!"

"Do you have goals?" my mother asked her. "I haven't planned any," she replied.

Darlene told us that she likes to ride horses. However, she just does this "for pleasure." Though currently unemployed, she has previously held down jobs working at Coles (a large grocery store chain in Australia) and as a bartender.

"You have nice eyes!" I told her. She smiled and said, "Thank you!"

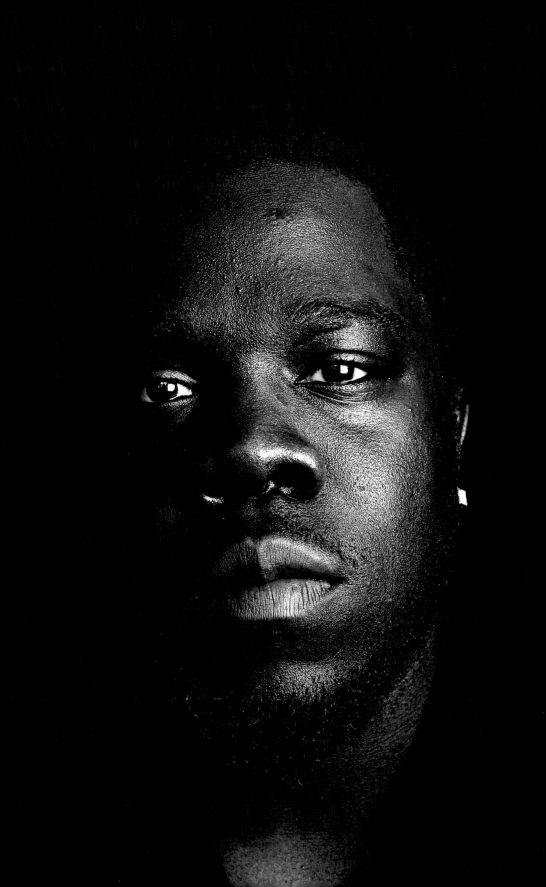

Peter

*M*atte Black, the CEO and founder of Heroes in Black, an organization that helps homeless and at-risk youth get back on their feet, arranged to have me take photos of three youth in his program. We met them at the Yonge-Dundas Square, a square on the southeast corner of Yonge St. and Dundas St. in Toronto. Peter, at 24 years old, was the elder statesman of the group. He told us that he has lived in Toronto his whole life, and has never been out of the city. Asked by my dad if he had ever heard of my home town of Collingwood, Peter said, "No."

"You'd probably like it there," my dad responded. "It has just 20,000 people. It's a rural place. There's hiking trails, as well as cows in the surrounding countryside."

When my dad asked Peter where he sees himself in five years, he seemed optimistic about what the future held in store for him. "Well, hopefully…um…I'm trying to do an apprenticeship with HRAC [Heating, Refrigeration and Air Conditioning], which is a trade…I plan on starting in January, and in five years, hopefully, I'll be doing it."

After I had taken Peter's photograph for a few minutes, he seemed to get a tad impatient, exclaiming, "Are you just taking the same photo over, and over, and over, and over, and over again?"

I replied, "Well, some of them don't turn out, and your expression changes as you talk." With a laugh Peter replied, "Yeah, true, true, true, true, true."

"What kind of hobbies do you have?" my dad asked Peter.

He replied, "I love to make music, I'm a rapper. I do the recording thing. Still have to perform, but I haven't yet. Right now I'm just trying to build my track list. So I'm in the studio recording. When I build my track list I'm going to start releasing videos, and then [I'll go] from the videos to the performances. I have connections. Thanks to social media, networking is so easy."

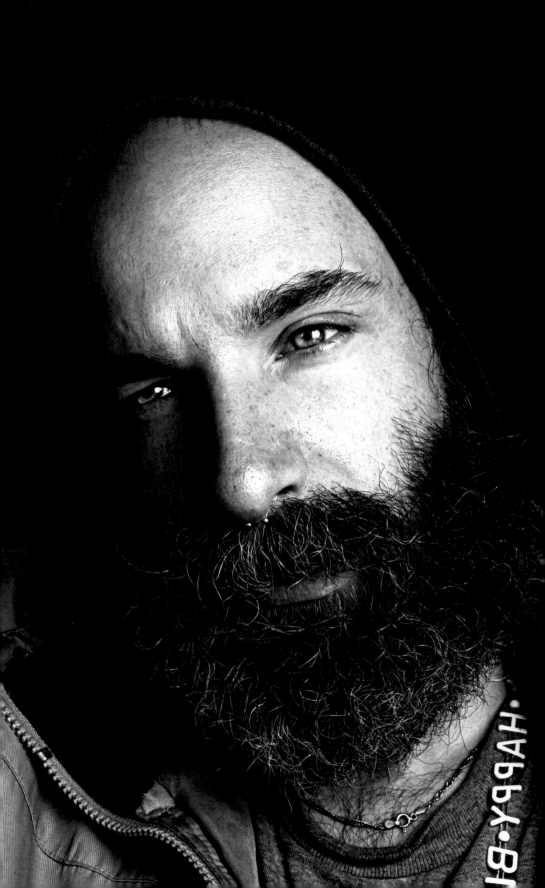

Frank

*I*t was an unseasonably mild late September afternoon. As my dad and I walked through a rundown neighborhood, we spotted Frank sitting on an old dilapidated easy chair in an empty lot across the road from the Salvation Army Windsor Community Rehabilitation Centre in Windsor, ON.

Frank told us that he is 30 years old and has lived in Windsor his entire life. While some of his family also live in Windsor, he said that he has a sister who lives in the nation's capital. "I've got a sister up in Ottawa… She comes down to see me. I've never been there yet. She's got a new house or something up there."

When my dad asked Frank if he had made friends at the Centre, he answered, "I've made a couple of friends." When asked if he had also made some enemies, he laughed and then replied, "I hope not."

As the photoshoot wound down, Frank offered to ask if some of the others at the Centre wanted to have their picture taken as well. "There's lots of, ah, guys that stay here that would like, you know…" he told my dad.

"Would you, maybe, be able to tell a few of them?" my dad asked him. "Let them know we'll pay them ten bucks." When Frank said that he would, my dad replied, "We'd appreciate that." (He eventually found three men for me to photograph.) Before the photoshoot came to a close, my dad said to him, "So you might be in a book. How does that make you feel?"

"That'd be nice," he replied.

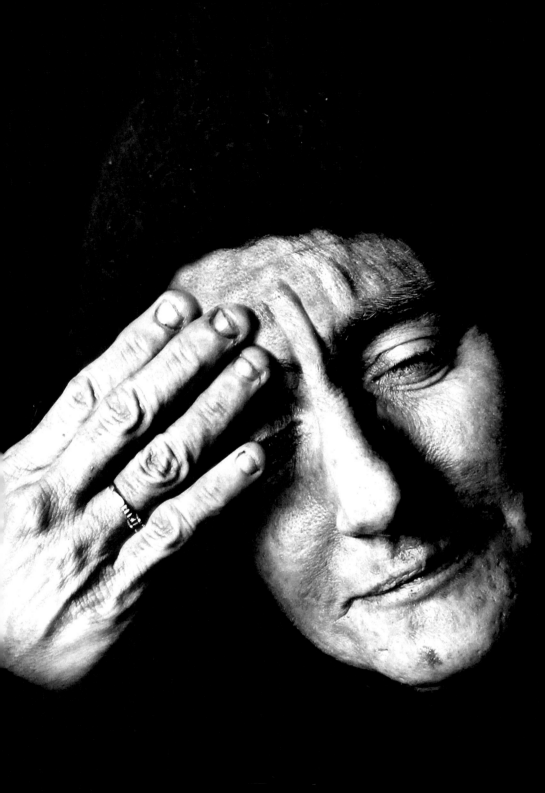

Sue

*W*hen my dad and I met Sue outside the Eaton Centre in Toronto on a brisk February day in 2018, she was sitting on the ground crying. In her hands, she held a cardboard sign that said, "I have depression and anxiety."

After wiping away her tears Sue told us that, although she is not currently homeless, she was up until about a year ago. "Right now I'm just trying to keep from being homeless… It's been quite a rollercoaster ride, let me tell you. Never a dull moment."

"So right now you have a place to stay?" my dad asked her.

"So far my landlord is very nice," she replied. "So I'm hoping…I'm hoping."

When asked by my dad if she had had a good day so far, Sue replied, "Well…it's had its ups and downs. The other…I was inside for a while doing this, but the guys…because I'm one of the few women that do this, the men kind of hurled a male dominance, 'I'm a guy, you're a girl, get the **** out of here!' You know? Threatened me… One guy was actually harassing me, and when the cops did show up, the first words out of their mouths were, 'What the **** did you do!' It's beginning to be hard to have faith in the police when they pull something like that. You know?"

Sue told us that she lost her mother when she was just a child and is estranged from her dad, with whom she hasn't spoken in fifteen years. "My mother died when I was eight," she said. "She succumbed to her addiction and I kicked it. I was having problems with the kids' father and I ended up in the demon. And I saw what I was doing and all I could see were my kids and I…"

"You didn't want to go the way of your mother?" my dad jumped in.

"That's right!" Sue exclaimed.

"Well, good for you!" my dad said, congratulating her.

"Yep, I've been clean now for fifteen years… My dad's out in Elliot Lake, but he kind of disowned me… When I became pregnant, my father pretty much gave me an ultimatum, 'Have an abortion or get the **** out!' So I got out. And then he also decided at the time to tell me that he's not my real father."

"So he's not your biological father?" my dad asked Sue.

"I don't know," she replied. "That's what he says. I don't know much of anything. My mother died. My father didn't tell me much. Nobody else seems to know. So your guess is as good as mine. Oh well!"

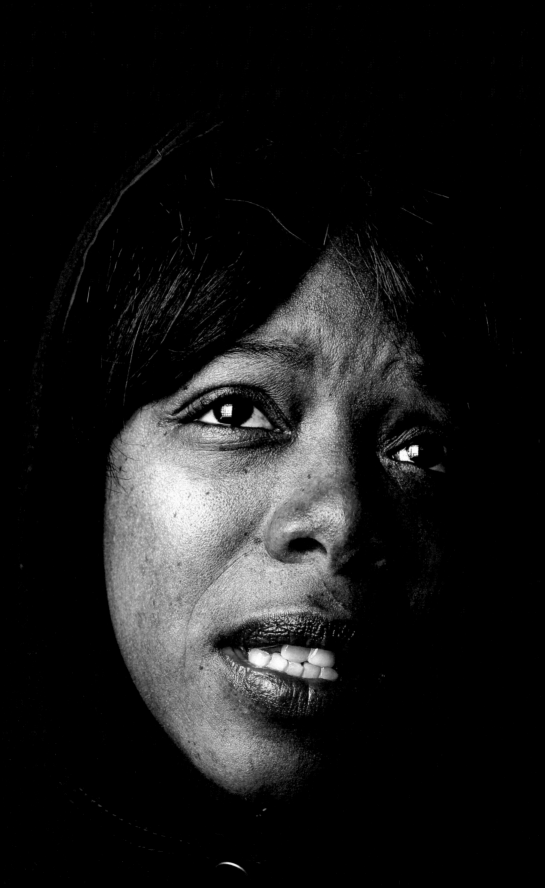

Grace

Grace told my dad and me that she has lived in New York City for twenty-nine years or all of her life. Like many of the younger generation of people experiencing homelessness who we have met, Grace's relationship with her family is strained, or, as she puts it, "iffy." However, she did say that she was "close with her aunts and cousins." When my dad said that he was glad to hear that because family is important, Grace replied, "Yeah, especially this time of year." (When we met Grace, it was almost December.)

Grace told us that she was currently living at the Life Women's Center. When my dad asked Grace if she liked it there, she replied, "The food could be better. But what do you do when you're homeless? Can't complain!"

"What about the staff?" my dad asked.

"The staff are all right," she said. "You gotta know how to talk to them. Some of them can be a little rude or iffy. They got attitude problems."

The staff at Life Women's Center, Grace told us, are helping her to find a job and get a place of her own. Ideally, she said, she would like to do secretarial work, as she was very organized and liked to multitask. "It's better than doing one thing and being bored," she told us.

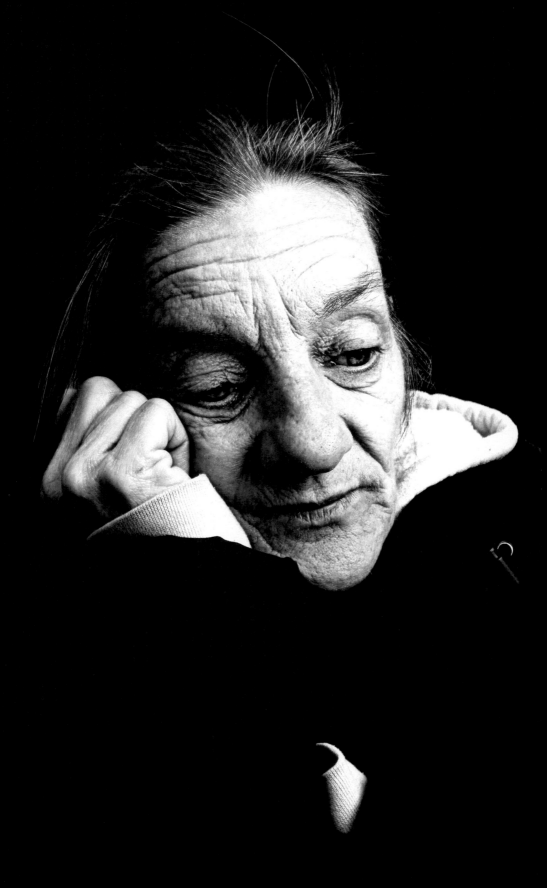

Paulette

*W*hen we met Paulette outside of the Welcome In Drop-In Centre in Guelph, she told us that she had once been homeless but was currently sharing a house with someone. However, she said this was about to change. "So you will have nowhere to go?" my dad asked her. "A friend and me are working on getting a place. But if I don't have a place by the end of the month, I'll just go to the [Dwelling Place Women's Shelter Program]."

"So you're going through a bit of a difficult time now?" my dad asked Paulette.

She replied, "Yeah. I was in the hospital last November for four days for an irregular heartbeat, and I've had three mini strokes in the past. I can usually feel them coming on and I just back away [and say to myself], 'Okay, enough is enough'… When I start feeling myself wound up inside, I just walk away from the situation… Well, I quit drinking ten months ago too. So for the sake of my sobriety, I've gotta walk away."

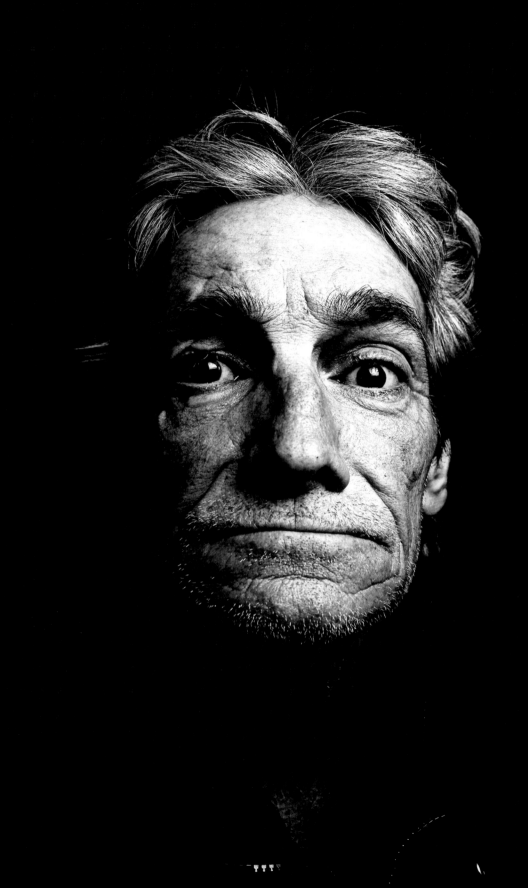

Robert

There was a sadness about Robert that was unmistakable. After my dad talked with him for a few minutes, the reason for his unhappiness soon became apparent. "It started about four years ago," he told us. "My family started dying off. I lost pretty much all of them. I have one brother and one sister out of seven of us... Mom and Dad went. My younger brother and sister...I lost my younger brother. It's been one year and a couple of days ago there. Cancer. He was 51. He was young. My sister committed suicide. She was 43. Dad, he wanted to go. He was 92. Dad had had enough. Mom followed shortly afterwards. Loneliness, I guess. Sixty-five years of marriage." Robert told us that he has been homeless since his dad died four years ago. "Ever since my dad passed away is pretty much when I got on the streets"

"You had a place before that?" my dad asked him.

"Oh yeah," he replied, "I had a *house*!" To make matters worse, Robert has fallen out of contact with his two sons, one of whom is a school teacher in Moncton, NB, and one of whom lives "somewhere" in Toronto. "Oh yeah, I haven't seen them in 20 years," he told us with a laugh that, despite his best efforts, couldn't hide his sadness.

When my dad and I met Robert, he was standing outside of the Booth Centre Men's Shelter in Hamilton, ON. When asked if he likes it in Hamilton, he replied, "I kind of grew up here. My brother was here working for Ford. So I've been gone over 35 years. When I came back, everyone I knew was pretty much gone... And the school teacher I was looking for, he passed away also. But I don't mind Hamilton. It's a pretty nice city."

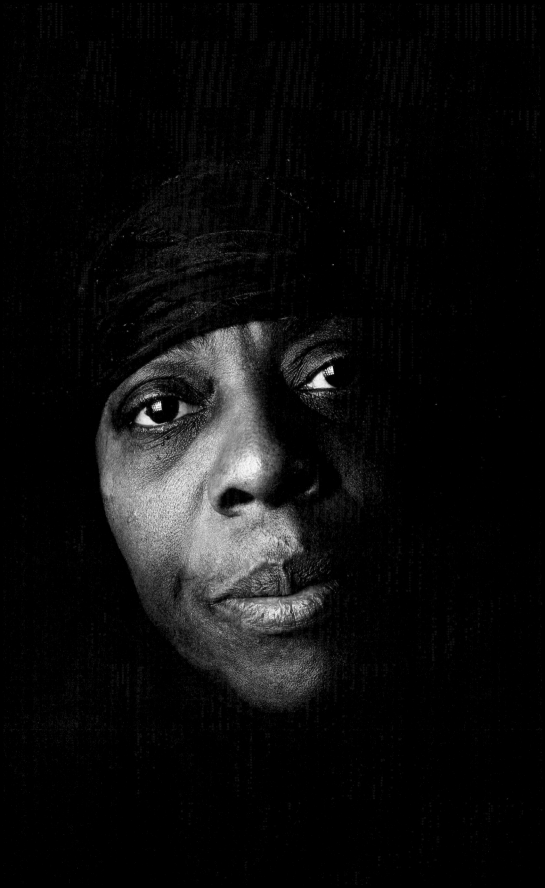

Genine

Genine doesn't ask a lot from life. "As long as my granddaughters is healthy, right, and safe and sound. What more could I ask for, besides an apartment? Those are the main things that I want: for my girls to stay healthy and be safe, and an apartment."

When my dad and I met Genine, she was staying at the Life Women's Center in Manhattan. When asked if she liked it there, her response was short and to the point: "No! I'm hoping," she went on, "by God's grace and mercy, to have an apartment by Christmas... There's an over-crowdedness with the females. Lots of different females, personalities, attitudes, things going on... My dorm has eleven [women]. There's no privacy at all, unless you go in a bathroom stall... But, I mean, it's a place to call home when you don't have a place to live."

Usually, my dad is the one who approaches people experiencing homelessness to see if I can photograph them. However, in the case of Genine, it is she who approached us. From a window in the shelter, she saw me photographing a fellow resident and decided to investigate. "I was nosy and wanted to see what you were doing," she told us. "I'm glad I did!"

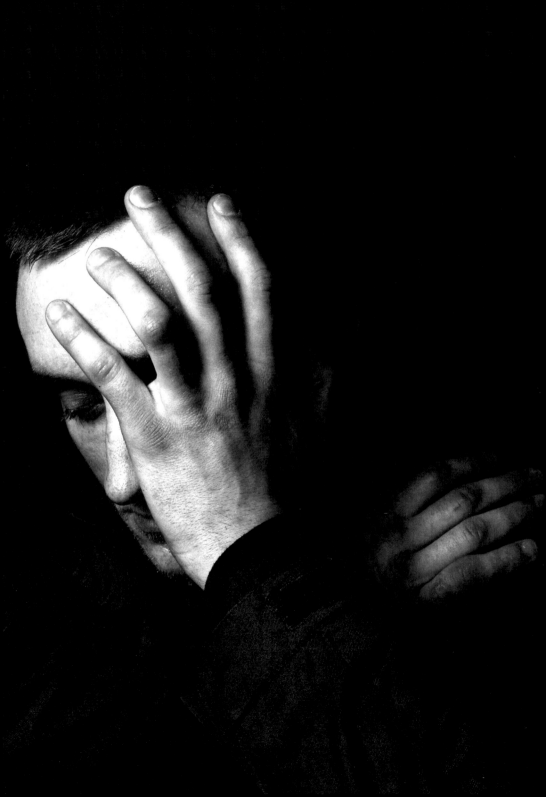

Patrick

My dad was delighted to find out, early in his conversation with Patrick, who is currently living at Youth Haven in Barrie, that he is a fellow Collingwoodite. Their conversation went as follows:

"I have no family around. My mom lives in Collingwood, but, ah…"

"Oh, Collingwood! That's where we're from."

"Oh, really?"

"Yeah, we came up here from Collingwood."

"Right on!"

"I've lived there all my life."

"Yeah, I grew up there too. Spruce Street."

"We live on Victory Drive, near…the high school."

"C.C.I. [Collingwood Collegiate Institute]?"

"Yeah, C.C.I."

"It's a good town, Collingwood."

"You think you might move back there some time?"

"Ah, probably not. No"

"So, you still have contact with your mom?"

"I talk with her on Facebook and stuff like that."

Patrick told us that he has just recently enrolled in a college program for culinary arts. "I like to cook!" he told us. For the first six weeks of the course, he has to go to Alliston, while the remainder of it is at Georgian College in Barrie. When my dad asked Patrick what food he likes to cook, he said, "Anything really!"

"Well, if you get a certificate or degree in that, you'll always find employment," my dad told Patrick, laughing. "There'll always be people eating, no matter how bad things get."

"Yeah, for sure!" he replied.

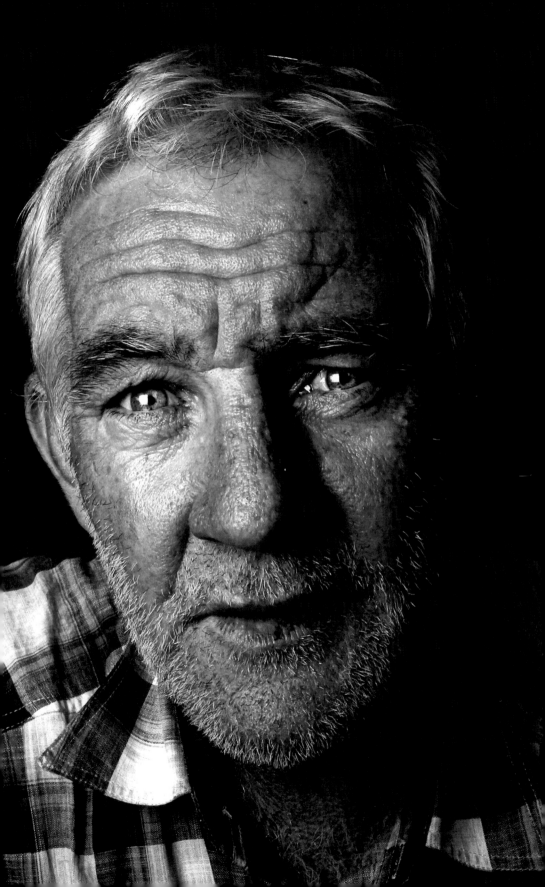

Terry

*W*ithin a minute or two of meeting Terry, who my mother and I found sitting on some steps on a busy street in Brisbane, Australia, he dropped a bombshell on us: "I've been diagnosed with only about a year to live or something. [I've maybe only got] six months. Liver cancer. I try now. I've sort of cut back on the alcohol." Terry then told us that he hopes, during the little time he has left, to see more of his daughters, all of whom live on the other side of Australia in North Hampton. "[I have] three girls," he told us. "The one daughter, [who is] 19, I haven't been in contact with for 18 years or something like that. [I would like to] spend more time with my children. That's what I'm going to do." Then, as if he didn't want us to feel sorry for him, he said, "But you know I've had a fortunate life. I've had a good life. You know what I mean? I've had healthy children. I've traveled the world. I've worked. You know what I mean?"

Despite the death sentence hanging over him, Terry had not lost his sense of humor. When my mother asked him what his philosophy of life was, he replied, "Uh, don't sneeze when you're hiding. Don't smile when you're lying. Um, and you only get out of [life] what you put into it. Never look down on someone unless you help them up."

Terry's last words to us were, "I won't be out here too long. I hope I'm going to get off the streets."

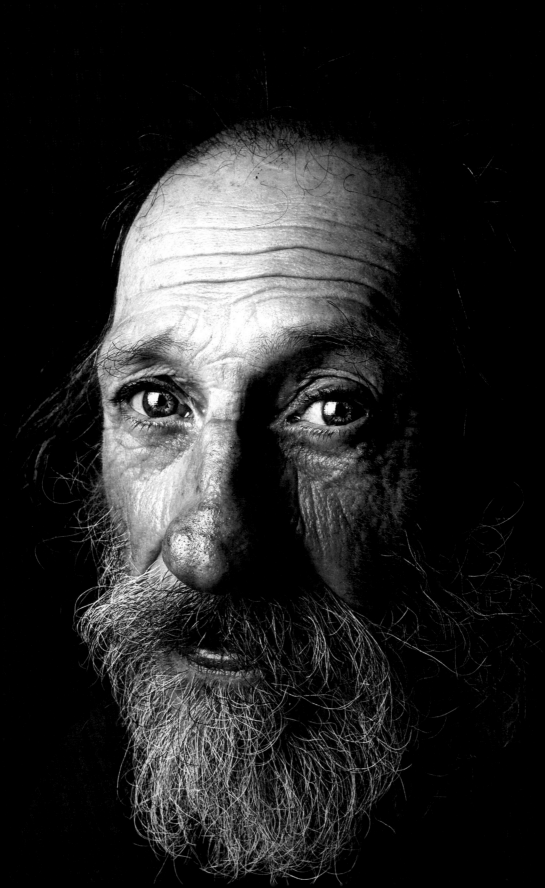

Kirk

hen we met Kirk, he was staying at the Salvation Army Booth Centre in Hamilton. However, he was expecting to soon get an apartment at the First Place Hamilton Seniors Residence. "It's a place where all the nurses are," Kirk told us. "I need a lot of help because I've got a bad heart… I'm on a waiting list to get in there." When my dad asked Kirk if heart problems run in his family, he replied, "Umm…yeah, my…umm…on my grandmother's side. She died from a bad heart… She just turned seventy when she died."

Although Kirk lives in Hamilton, he doesn't consider it home. "Burlington's my home town. My grandparents brought me up since I was ten."

"So they were your mom and dad basically?" my dad asked Kirk.

"Yeah," he replied, "but they're both gone now. The last one to go was my grandfather. He drowned in the bathtub." Kirk told us that he has two brothers who were brought up by their dad. When asked if he was close to them, he said, "No, they always told everybody off!" Kirk told us that he has three children who are in their 30s and 40s. "I see one of them, but I don't see the others," he said.

"They're not interested?" my dad asked.

He replied with a simple, "No."

To get the right shot, it was necessary for me to position my camera, at times, about 30 centimeters from Kirk's face. Seeing his discomfort, my dad asked him, "You ever had a camera right in your face like that before?"

Kirk answered with an emphatic, "No! Never have!" at which we all laughed.

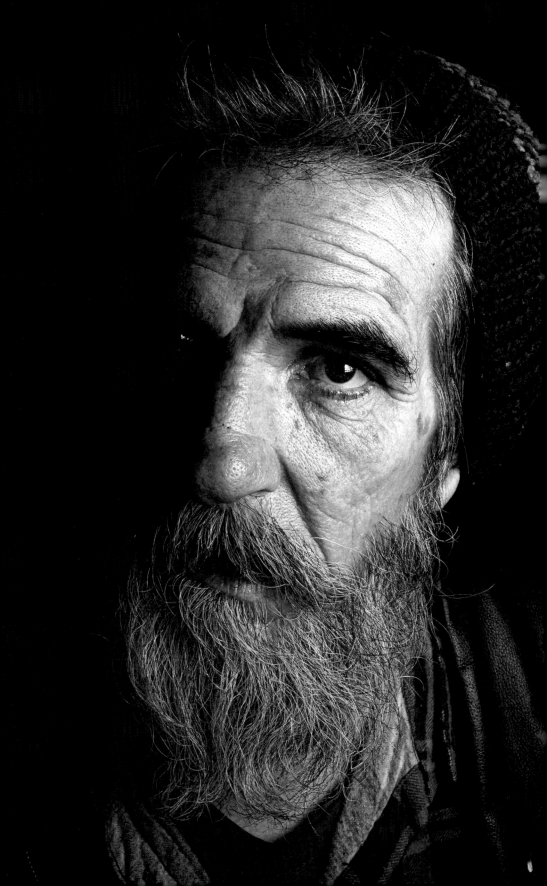

Raymond

*W*hen I first spotted Raymond, he was sitting on a park bench outside of a strip mall in Brisbane, Australia. He was leaning forward with his face in his right hand and looked very depressed. I began getting my photography equipment together. However, when, a couple of minutes later, I looked up, Raymond was nowhere in sight. Scanning the crowd, I saw him about to enter a mall. I quickly ran over to him and asked if I could take his picture. When he said that I could, I set up my backdrop and flash against a wall in the mall.

"Are you in contact with your family?" my mom asked Raymond.

He replied, "Uh, sort of. I have one child who is a girl, but she moved to Melbourne. Yeah, [I'm a grandfather too], and all my sisters are grandmothers. [My father] died of cancer. He died in 2002. My mom died in 2007."

Raymond told us that although he was not currently homeless, he had been recently. He said, "I realized [being homeless] was hard [and] that's when I started going to charities for support." Raymond went on to say that he has received help from Micah Projects, The Salvation Army, and St. Vincent de Paul.

"Where were you born?" my mom asked Raymond.

"I was born at The Royal Brisbane," he replied.

"Is that a place in Brisbane?" my mom asked him.

Laughing, Raymond exclaimed, "[No], it's a hospital!"

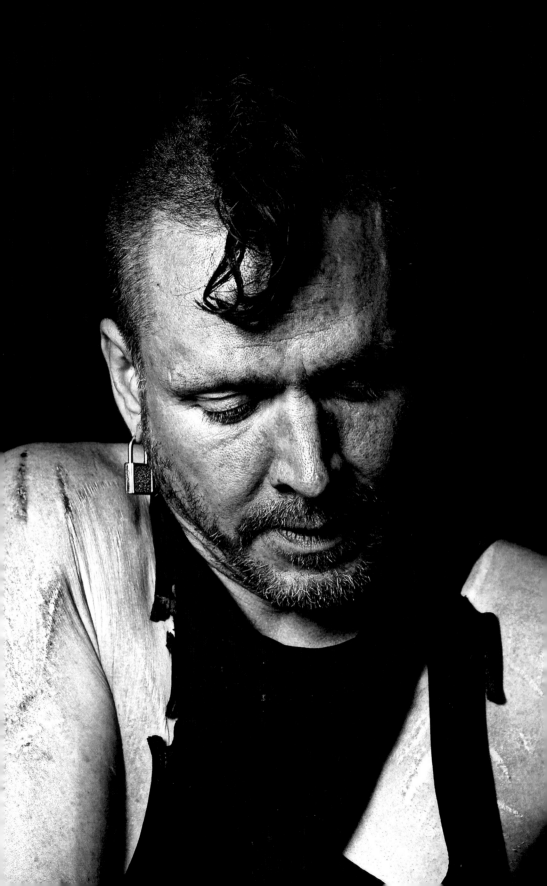

Dexter

"**I**'m an open book," Dexter declared to my dad at the beginning of his interview with him. He wasn't kidding. For no sooner had my dad begun to ask him some questions, than Dexter opened up to him about a horrific event, in 2001, that shook the foundations of his world.

"I used to live in [Osaka, Japan] until my wife and son died…ah, drunk driver. My son was 15 years old. Ah, my wife was taken back for a medical exam. I could've taken a day off, but I didn't. Instead, I went to work and because of that, ah, she took the subway and, ah, got hit by a drunk driver, and, ah, eight other people also got hit that day. And, ah, I kind of got myself down about that."

"Sorry to hear about that," my dad said to Dexter.

When asked if he was doing okay, Dexter replied, "For the most part." Then, quoting the German philosopher, Friedrich Nietzsche, he said, "What doesn't kill you makes you stronger."

When we met Dexter, he was living by himself in a tent under the Gardiner Expressway in Toronto. But not for long. With the $10 my dad paid him for modeling for me, he finally had enough money to buy the parts he needed to fix up his "wagon"—a pedal bike with a trailer attached to the back. He is then going to bike to Vancouver. "I could live better than I do," he admitted to my dad, "but, ah, for me this is real. Every day that I wake up…I want to live."

Dexter also told us that he did three tours of duty in Iraq before being taken prisoner. He has several scars on his shoulders and arms to show for it. And despite referring to himself as a "dumb donkey," he speaks no less than 13 languages. (During my dad's interview with him, Dexter spoke to him in Arabic, Italian, German, French, Japanese, and Russian.)

Despite all of his hardships, Dexter said that he wouldn't change a thing. "I wouldn't trade any of the bad for the, ah…even with my wife and son, because if you do, you know, it doesn't change things… If you love someone, you never want to change anything 'cause you know they wouldn't be the same person. It's the same with life. [You never want to] change anything that happens because all the good things that come along you'll miss out on."

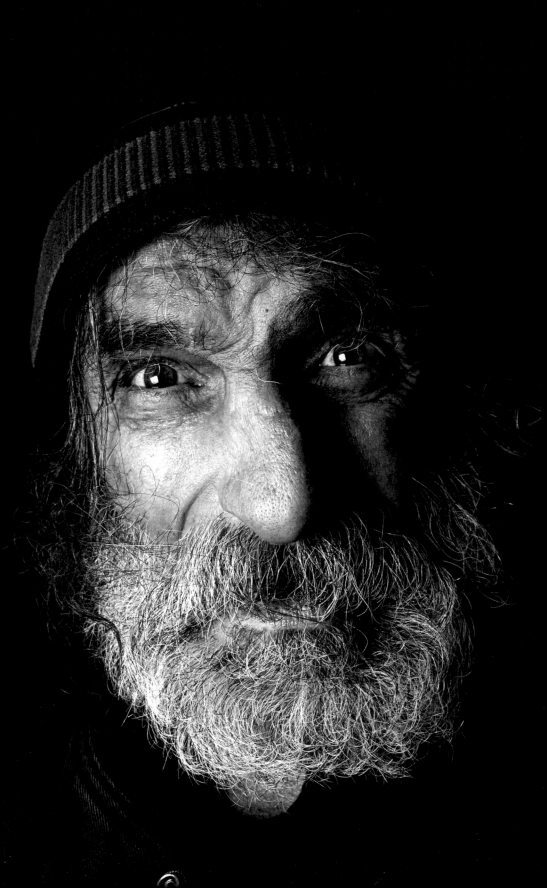

Tony

*I*t was a mild and windy March day in 2018 when we came across Tony. He was sitting on the busy corner of Richmond and Bay Street in Toronto panhandling. My dad walked up and introduced the two of us. Tony cheerfully echoed our names back to us saying, "Tim and Leah, yeah." After my dad explained to Tony what we were doing, he happily agreed to have his photograph taken. Throughout the photoshoot, Tony quietly whispered, sang, and hummed to himself. Here is a sample of my dad's interview with Tony:

"What is your name?"

"Tony, Tony, Tony."

"How long have you lived in Toronto?"

"All my life, all my life, all my life."

"Do you have any family here?"

"Yeah all of them. But some of them died [off] quickly."

"Are your parents still alive?"

"No, no, no."

"It's windy today!"

"Yeah it's kinda windy, it's kinda windy."

"Where do you stay when it gets really cold?"

"Fred Victor, Fred Victor, Fred Victor."

When the photoshoot was finished and my dad took $10 out of his pocket to pay Tony for modeling for me, he gleefully said, "Thank you, thank you, thank you."

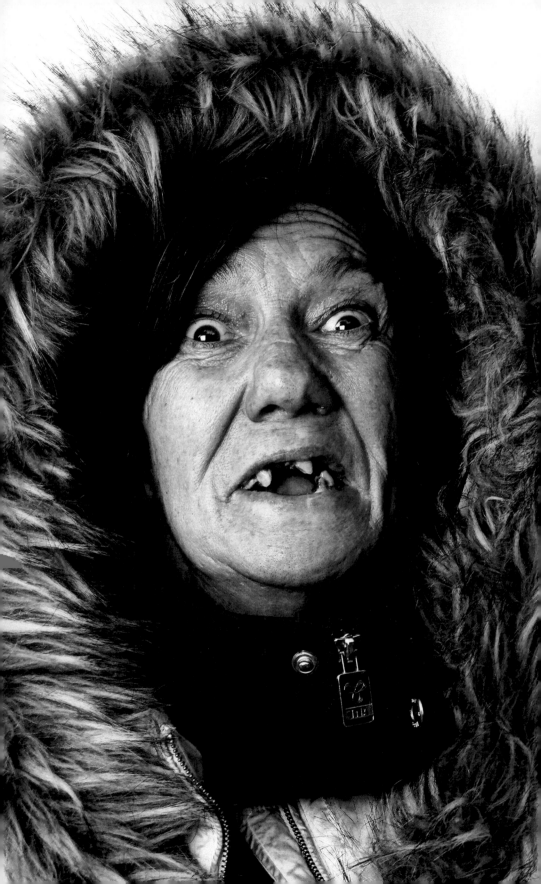

Joanne

"Excuse me, do you have some change?" My dad and I turned to see Joanne, a middle-aged woman, looking at us with an outstretched hand. She was dressed in a winter coat with the hood on (despite the fact that it was a mild spring day). When my dad told her he would pay her $10 if she would model for me, she was positively ecstatic. "But first I have to go to the washroom," she said, which she promptly did beside an abandoned building.

"I grew up right in this area here when this disaster happened behind me," Joanne told my dad and me, gesturing to several abandoned and boarded-up buildings that loomed behind us. She went on to elaborate:

"Oh, they shut the whole thing down. The whole building was closed down, I was involved in that. A lot of drug dealers and ****, they were all in here. But then… [they] ******* destroyed the whole thing… But they had no right…to demolish everything. Well, listen I was the owner of one of the space missions. So, I, uh…was, uh… [a] medical doctor-type and owned the drug ring. And they wiped it out…wiped it out. And that was the space mission. And I got murdered…and I got robbed by the cops…"

When my dad asked Joanne how long she has lived in Toronto, she replied, "Uh, all my life, all my life. Yeah, but we're not in Toronto." My dad assured Joanne that we were in Toronto, and asked her if that was where she had grown up. She replied, "Yeah Scarborough." The conversation then turned to the subject of family. When asked if she had any, Joanne replied, "Yeah, they're wanted for robbery. They're getting the lethal injection. They robbed my money. They're getting the death sentence, the lethal injection, the needle. They put me in prison and they used me for robbery. And they killed my kid…" She then said, "I don't want to talk about this."

And so to change the subject my dad asked her, "So you're enjoying the sunny weather?"

Joanne replied, "When it gets cold I hate it—when it's 40 below on King Street. Oh, it's beautiful. Yeah, [it's] gorgeous. Who doesn't like summer? Like, you can do anything you want."

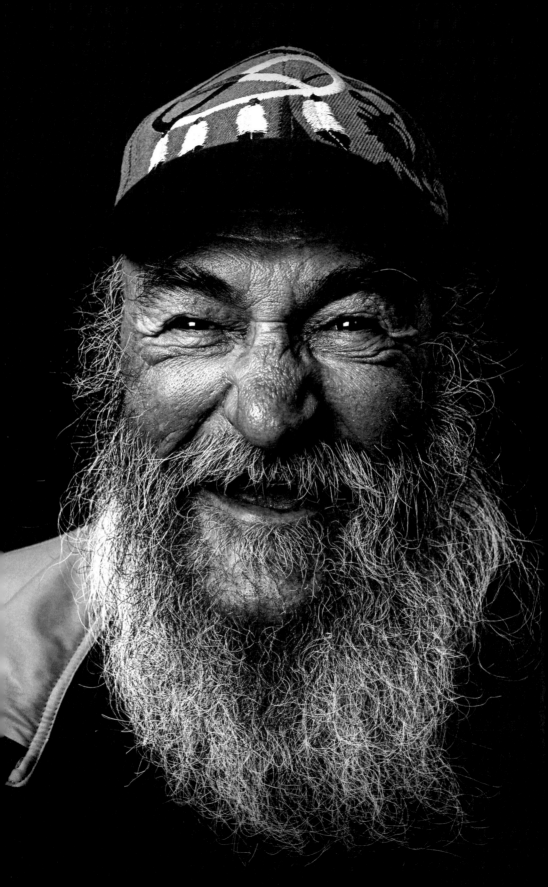

Leonard

*W*hen we met Leonard, he was sitting, cross-legged, at the corner of Adelaide and Bay streets in Toronto. Resting on his lap was a big cardboard sign that drew many a chuckle from passersby. It read: "Broke and Sexy, anything will do. Thanks and God Bless." The sign also had a happy face with the caption, "Happy, Happy, Happy"—a word that appears to capture Leonard's character well. For throughout my 10-minute photoshoot with him, he had a smile that lit up his face. And on more than one occasion, he laughed uproariously.

But despite Leonard's brave front, life has not been easy for him. When, in response to his comment that he has a daughter who is a nurse, my dad said, "So if you get sick, you know who's going to take care of you, eh?" he replied,

"That's right. Well, I'm pretty sick as it is. I'm a seven-year survivor of cancer. All natural healing, people praying over me. I'm doing pretty good, [but] I'm still in a lot of pain with bone marrow. And up my lower back has deteriorated. But other than that, I'm doing pretty good, you know. [But I] gotta walk with a cane. I don't get help from the government. That's why I sit out here. I don't know. More times than I can remember, I got turned down…for disability. [It's] because I refused treatment and went all natural. I basically fend for myself. I've been on the streets for almost twenty years now. I won't stay in a shelter… [There's] bed bugs, [and] you gotta basically keep everything tied onto you, because if you don't, you're going to lose everything. [However], I go to the Out Of the Cold [programs] in the winter. It's run by churches."

Leonard has, for the past several years, been hitchhiking back and forth between Toronto and Halifax. However, he told us that his declining health may soon make this impossible: "…it's a little bit harder to get around with the cane… [That's why] I've been thinking of settling down. If I got backing from the government, it would be different. [If I did] then I could settle down, right? [And] I could afford rent. But I can't afford rent. [I] barely make enough out here to survive each day. So it makes it hard. But I keep a smile on my face [and try to] be happy all the time."

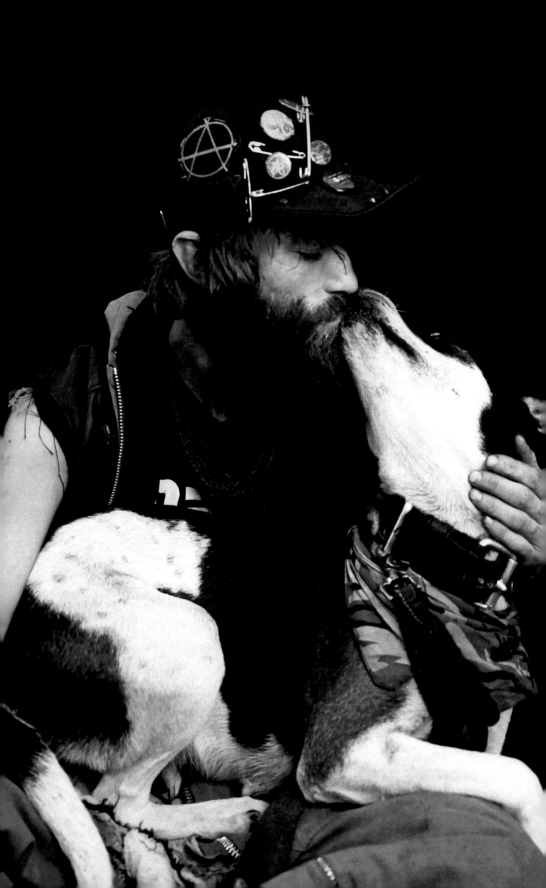

No Body Nate and Kona

a few minutes before approaching No Body Nate—the name he goes by—my dad and I observed him kissing a woman goodbye across the road from the Ryerson University Student Learning Centre in Toronto. We were to learn later that, although she is his recently reunited girlfriend, she has put him on probation—to see if he can stay clean from drugs. "How has that been going?" my dad asked him.

"Good!" he replied. Then, holding out his upturned arms to my dad, he said, "See, no track marks."

But his girlfriend is not the only female in No Body Nate's life. The other female is his dog Kona, who, No Body Nate told us, is part husky, pitbull, and bouvier. "She is two and a half," he told us. "I've had her since she was one and a half. I'll have had her for a year on July 2. [The photoshoot took place on June 27.] Before her, I had a cane corso pitbull mastiff, a $2,800 dog. I got him for free… I raised him for twelve weeks. I only had him for three or four months. Something like that." When my dad asked No Body Nate if the dog died, he replied, "No, I got arrested. In Texas if you get arrested they immediately take your dog and put him in a pound and adopt him out within 3–5 days."

"You must miss him," my dad said.

"Absolutely!" No Body Nate replied. "[He was] the only male puppy I've ever raised."

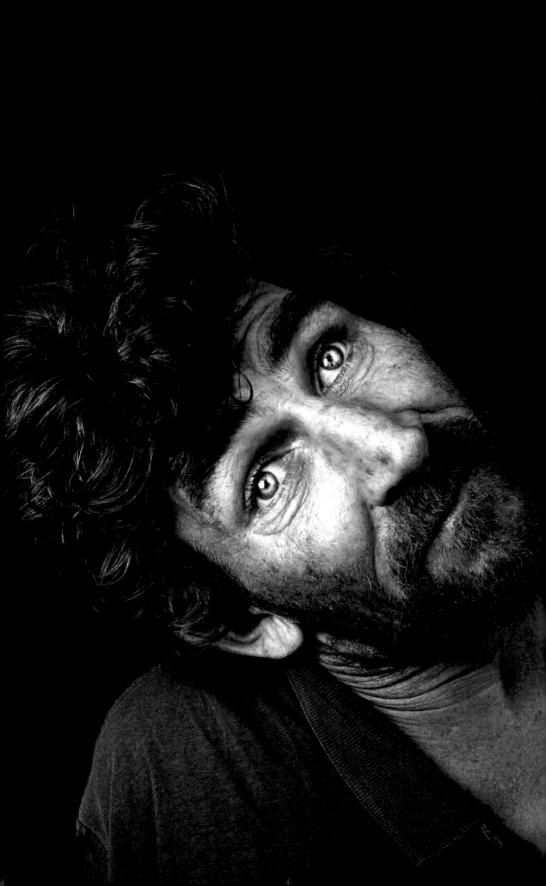

Christian

Christian told us that while growing up in Sydney, Australia, he always felt that his mother—who was an Africaner (i.e., a white person from South Africa whose ancestors are Dutch)—was keeping a dark secret from him. This eventually became a matter of contention between the two of them. "I got fed lies and lies and lies! When I grew up, I got lies and lies and lies. And I wanted to find out for myself. When I grew up, I didn't belong." Sensing Christian's discomfort, my mother tried to change the subject, "Where do you see…" But Christian wasn't finished.

"When you feel you don't belong, you're going to ask questions. And I did. And I found out for myself, when they confessed." The painful truth he learned is that he was conceived out of rape. "My mother got raped!" he told us. He would eventually become estranged from his mother—who would go on to die from a drug overdose—and at the young age of 17, find himself on the street. When we met him, he had a bag of bedding and clothes. "That's what I live out of."

Christian has one child but is forbidden from having contact with him. "I have a son I can't see. When my son was born, she claimed it was someone else's baby, and… yeah. I couldn't be there for his birth. Nothing!"

Surprisingly, despite all of the difficulties that he's experienced in his life, Christian spent much of the 14-minute photoshoot that I did with him, hamming it up for the camera. His array of silly poses left my mother in stitches. At one point he held up the can of beer he was drinking—a brand called Wild Turkey—and yelled, "Aussie, Aussie, Aussie!" He then offered my mother a beer. "No thanks, I don't drink," she replied.

"You don't drink? Smart! Very smart!" he responded, tapping his temple with his index finger.

Christian, we were to learn, is a horse trainer by trade. Asked if he plans on doing this again, he replied excitedly, "Yeah, yeah! What I'm going to do, my plan in life is I'm going to travel around…travel around on horseback on the…around Australia, and raise awareness for homeless people, and raise money for homeless people."

When the photoshoot was over my mother said to Christian, "You're a very nice man, Christian!"

"Yeah, I'm tough," Christian replied while flexing his arm muscles.

Laughing, my mom responded, "You're a happy, tough guy!"

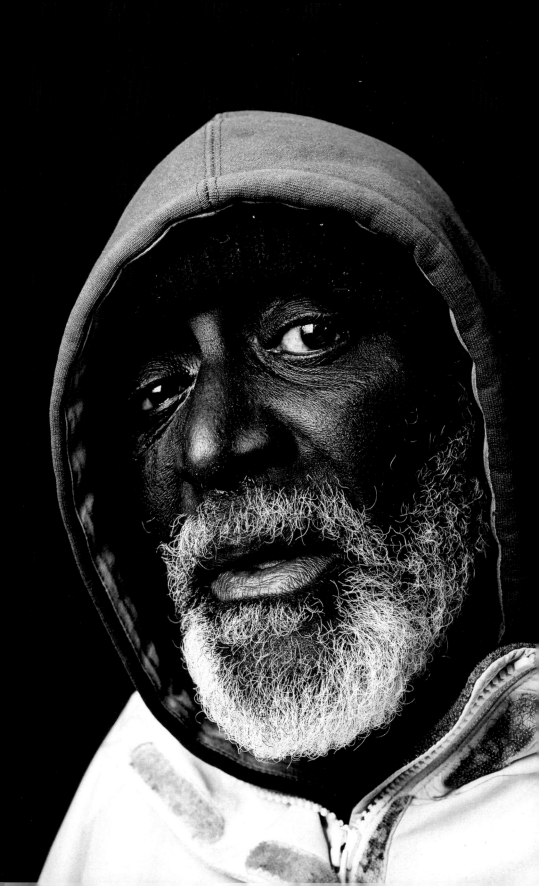

"Pops"

*W*hen my dad and I met "Pops" in the lower east end of Manhattan, he was in poor health. "I'm having trouble breathing," he told us, "and my legs is swollen up. That means there's water, because I have heart failure." "Pops" had several coughing fits during my photoshoot with him. They were so frequent and violent, in fact, that were a few times when I wasn't sure if we would be able to continue with the shoot. It doesn't help matters that, as an acquaintance of "Pops" told us, he often spends the night in the park on a bench.

Aggravating the situation is the fact that "Pops" has no family around. "My family moved out of state," he said. "But [my ex-wife] doesn't want me to know. And I think that messes with me...with my head, you know. When you get older you want to integrate with family, you know." When my dad commented that this must be hard on him, he replied, "Yeah, it's hard. But I have to do things for myself, you know. I have to take care of myself which is very important, because, um, I want to live a little, you know."

"Pops" told us that he has a son who he hasn't seen in years. "He was coming around regular. Then one time he came to the reunion that we have here every year. But I wasn't here. And since the reunion, he hasn't showed up again. That's been about 3–4 years."

Despite the fact that the photoshoot with "Pops" took place at the end of November, the temperature was still quite mild. When my dad commented on this, "Pops" laughed and said, "Yeah, we got away with murder."

Conclusion

This past September, I began studies at Sheridan College in Oakville, Ontario. I am taking a four-year Bachelor of Photography program. I've been told that without a degree, it would be very difficult for me to get hired as a photographer by a magazine or newspaper. I expect that during this time, the work I am doing with people experiencing homelessness will slow down—slow down, but not stop. With the help and support of my parents, I will continue with my mission of trying to change the general public's negative perception of people experiencing homelessness. In fact, by the time some of you read this, volume four will probably already be nearly complete and ready to send to the publisher. Thank you for your continued support!

Resources:

Organizations That Help People Experiencing Homelessness

Raising the Roof
raisingtheroof.org

Covenant House
covenanthousetoronto.ca

Salvation Army
salvationarmy.ca

Dixon Hall Neighbourhood Services
dixonhall.org

The Scott Mission
scottmission.com

Inn from the Cold
innfromthecold.ca

Missionaries of Charity
peopleof.oureverydaylife.com/donate-missionaries-charity-6132.html

Hope Mission
hopemission.com

The Lighthouse
lighthousesaskatoon.org

Old Brewery Mission
oldbrewerymission.ca

Bissell House
bissellcentre.org

Home Horizon
homehorizon.ca

Coalition for the Homeless
coalitionforthehomeless.org

Homes First
homesfirst.on.ca

Young Parents No Fixed Address
ypnfa.com

I Have A Name
ihaveaname.org

Horizon House
horizonhouse.ca

St. Francis House
stfrancishouse.org

Habitat for Humanity
habitat.ca

United World Voices
unitedworldvoices.org

Mission Services
mission-services.com

Heroes in Black
heroesinblack.ca

Ve'ahavta
veahavta.org

Welcome In Drop-In Centre
www.ibvm.ca/works/justice/welcome-drop-in

Canadian Alliance to End Homelessness
http://caeh.ca

The Lighthouse Soup and Kitchen
orillialighthouse.ca